Rembrandt van Rijn: 141 Etchings and Drawings

By Narim Bender

First Edition

Rembrandt van Rijn: 141 Etchings and Drawings

Foreword

Rembrandt Harmenszoon van Rijn was a Dutch painter and etcher. He is generally considered one of the greatest painters and printmakers in European art history and the most important in Dutch history. His contributions to art came in a period of great wealth and cultural achievement that historians call the Dutch Golden Age when Dutch Golden Age painting, although in many ways antithetical to the Baroque style that dominated Europe, was extremely prolific and innovative.

Having achieved youthful success as a portrait painter, Rembrandt's later years were marked by personal tragedy and financial hardships. Yet his etchings and paintings were popular throughout his lifetime, his reputation as an artist remained high, and for twenty years he taught many important Dutch painters. Rembrandt's greatest creative triumphs are exemplified especially in his portraits of his contemporaries, self-portraits and illustrations of scenes from the Bible. His self-portraits form a unique and intimate biography, in which the artist surveyed himself without vanity and with the utmost sincerity.

Among the more prominent characteristics of Rembrandt's work are his use of chiaroscuro, the theatrical employment of light and shadow derived from Caravaggio, or, more likely, from the Dutch Caravaggisti, but adapted for very personal means. Also notable are his dramatic and lively presentation of subjects, devoid of the rigid formality that his contemporaries often displayed, and a deeply felt compassion for mankind, irrespective of wealth and age. His immediate family — his wife Saskia, his son Titus and his common-law wife Hendrickje — often figured prominently in his paintings, many of which had mythical, biblical or historical themes.

In his paintings and prints he exhibited knowledge of classical iconography, which he molded to fit the requirements of his own experience; thus, the depiction of a biblical scene was informed by Rembrandt's knowledge of the specific text, his assimilation of classical composition, and his observations of Amsterdam's Jewish population. Because of his empathy for the human condition, he has been called "one of the great prophets of civilization."

Rembrandt was born in Leiden on July 15, 1606. He was the son of a miller. His parents took great care with his education. Rembrandt began his studies at the Latin School, and at the age of 14 he was enrolled at the University of Leiden. The program did not interest him, and he soon left to study art - first with a local master, Jacob van Swanenburch, and then, in Amsterdam, with Pieter Lastman, known for his historical paintings. After six months, having mastered everything he had been taught, Rembrandt returned to Leiden, where he was soon so highly regarded that although barely 22 years old, he took his first pupils. One of his students was the famous artist Gerrit Dou.

Rembrandt moved to Amsterdam in 1631; his marriage in 1634 to Saskia van Uylenburgh, the cousin of a successful art dealer, enhanced his career, bringing him in contact with wealthy patrons who eagerly commissioned portraits. An exceptionally fine example from this period is the Portrait of Nicolaes Ruts (1631). In addition, Rembrandt's mythological and religious works were much in demand, and he painted numerous dramatic masterpieces such as The Blinding of Samson (1636). Because of his renown as a teacher, his studio was filled with pupils, some of whom (such as Carel Fabritius) were already trained artists. In the 20th century, scholars have reattributed a number of his paintings to his associates; attributing and identifying Rembrandt's works is an active area of art scholarship.

In contrast to his successful public career, however, Rembrandt's family life was marked by misfortune. Between 1635 and 1641 Saskia gave birth to four children, but only the last, Titus, survived; her own death came in 1642 - at the age of 30. Hendrickje Stoffels, engaged as his housekeeper about 1649, eventually became his common-law wife and was the model for many of his pictures. Despite Rembrandt's financial success as an artist, teacher, and art dealer, his affinity for ostentatious living forced him to declare bankruptcy in 1656. An inventory of his collection of art and antiquities, taken before an auction to pay his debts, showed the breadth of Rembrandt's interests: ancient sculpture, Flemish and Italian Renaissance paintings, Far Eastern art, contemporary Dutch works, weapons, and armour. Unfortunately, the results of the auction - including the sale of his house - were disappointing.

These problems in no way affected Rembrandt's work; if anything, his artistry increased. Some of the great paintings from this period are The Jewish Bride (1665), The Sampling Officials of the Drapers' Guild (1662, Rijksmuseum, Amsterdam), Bathsheba (1654, Louvre, Paris), Jacob Blessing the Sons of Joseph (1656), and a self-portrait (1658, Frick Collection).

His personal life, however, continued to be marred by sorrow. His beloved Hendrickje died in 1663, and his son, Titus, in 1668 - only 27 years of age. Eleven months later, on October 4, 1669, Rembrandt died in Amsterdam.

Drawings

Rembrandt was one of the greatest draftsmen in the history of art. His production of drawings was as creative as it was dazzling. About 1400 attributed to him drawings survive, and probably at least an equivalent number have been lost. Rembrandt made comparatively few preparatory studies for his paintings and even fewer highly finished drawings - gifts for friends and followers. Usually his drawings were unrelated to his major works and were, moreover, unsigned; only about 25 that bear his signature are known.

Experts estimate the dates of Rembrandt's drawings by studying his style the way he used his favorite media: red and black chalk, ink and quill or reed pen, brush and washes. How much has been lost as a result of negligence, ignorance, fire? Fifty per cent is a conservative estimate. By any count his output as a draughtsman was prodigious. He must have made drawings as readily as he breathed.

Although it was Rembrandt's practice to sign and date his paintings and etchings, he almost not ever inscribed his name on his drawings. Only about two tens bear his signature. In the final analysis most drawings must be ascribed to him on the basis of conclusions about their style.

Like other artists he drew preparatory studies far his paintings and prints, but he did not make many drawings of this type. Those executed as finished works, complete in themselves, are even rarer. The selection in this book gives us a good idea of Rembrandt's range, depthand drawings techniques. It includes self-portraits, portraits; sketches, women gossiping, or people merely watching the passing scene; studies of Jewish types and Orientals; drawings of nudes, birds, domestic animals and captive wild beasts, studies of the landscape, drawings of episodes from the Bible.

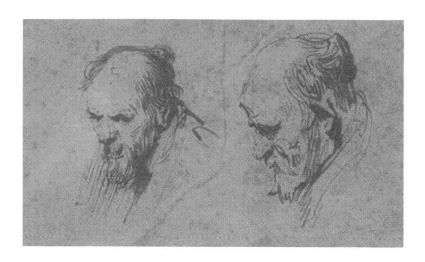

Two Studies of the Head of an Old Man
1626, Pen and brown ink, torn down the center and rejoined,
Paul Getty Museum

In his bold, vigorous, and economical style, Rembrandt examined this man's pensive face from two directions. He presented the eyes as dark caverns, with shadows alone defining the ear, cleverly allowing the blank paper to do the rest. Broad pen strokes develop areas such as the neck, shoulder, and back of the head. Rembrandt often preferred to draw and paint older figures, subjects whose greater life experiences showed in their faces.

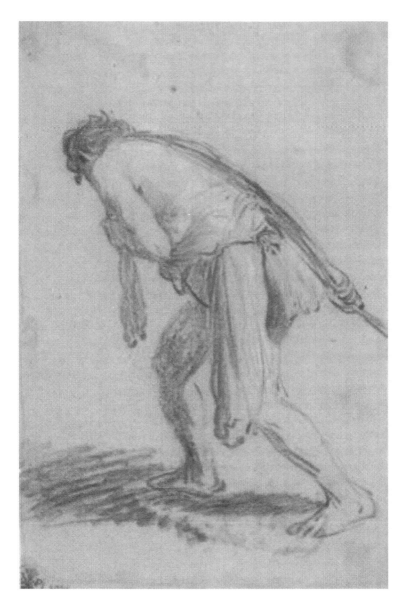

Man Pulling a Rope
1627-1628, Staatliche Graphische Sammlung, Munich

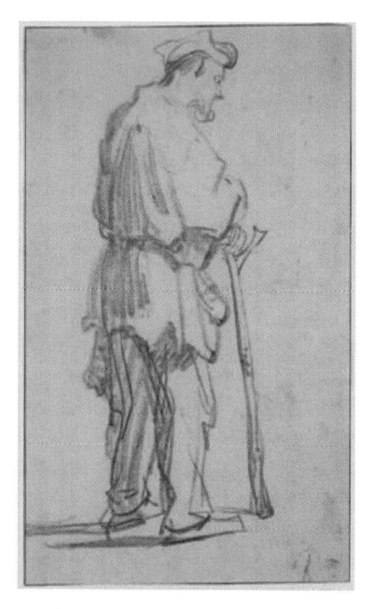

Standing Beggar Turned to the Right
1628-1629, 29.2 x 17 cm, Rijksprentenkabinet, Amsterdam

11

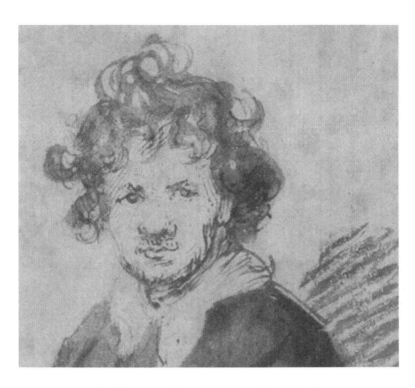

Self Portrait with Tousled Hair
1629, 127 x 94 mm, Rijksmuseum, Amsterdam

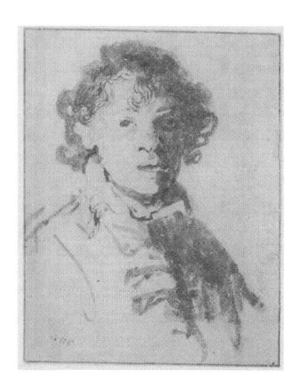

Self Portrait, Open-Mouthed
1629, 127 x 95 cm, British Museum, London

Rembrandt first drew the face and collar with pen and brown ink. The line is fluid and strongly applied, although it has faded with time. He then drew in the hair, the unlit part of the coat and the dark side of the face with broad sweeps of the brush and grey wash. It is likely that Rembrandt drew himself under a strong artificial light from the left, as a second layer of grey wash reinforces the central line of darker shadows that divides the lighter from darker areas. The white of the paper alone suggests the dramatic light.

The portrait has been ruled at the edges to create a frame. Rembrandt's promotion of his self-image through numerous self-portraits in paintings, engravings, etchings and drawings is well known. This rapid sketch, one of his first self-portraits, was made when Rembrandt was between 22 and 23 years old.

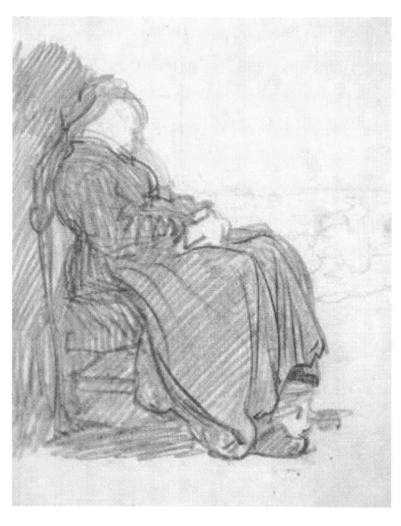

A Study of a Woman Asleep
1629-30, 250 x 220 mm, Kupferstichkabinet, Staaliche Kunstsammlungen, Dresden

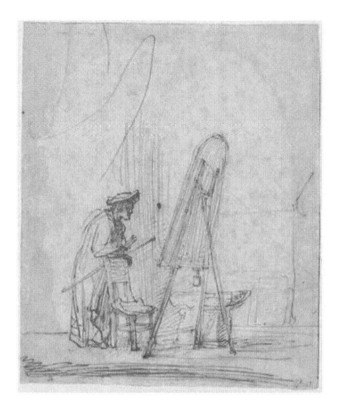

An Artist in His Studio
1630, Pen and brown ink, Paul Getty Museum

Using only pen and ink, which shows every mistake, Rembrandt created the space and volume of an artist's studio with a spare use of line. He drew the easel and the painting first, as the point of reference for the artist and the other objects. He later added the perspective lines that converge beyond the right edge of the paper; they served to confirm his intuition about the correct construction of objects in space. The heavier reinforcing lines at the bottoms of the chair and easel indicate adjustments to their placement.

Some scholars have labeled this drawing as a self-portrait in which Rembrandt himself views a panel from a distance, developing a mental image of the whole picture before he begins to work. Alternatively, other scholars argue that it depicts Rembrandt's friend and fellow Leiden artist Jan Lievens, who began his pictures by making a rough sketch in paint directly on the canvas.

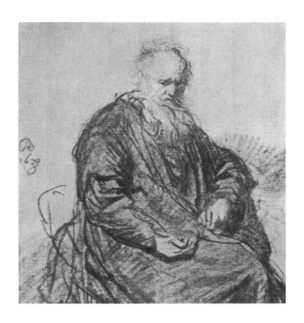

Seated Old Man
1630, black chalk, National Gallery of Art, Washington

Seated Old Man, initialed by Rembrandt and dated 1630, exhibited at the National Gallery of Art, is one of a number of studies from life of the model for his painting A Scholar Seated in His Study. This black-chalk drawing shows the model in three-quarter-length view, sitting with his left elbow resting on the arm of a chair, which is entirely hidden by the folds of his cloak. A strong light strikes the head nearly full-on and from the upper left, so that the illuminated side of the head blends almost imperceptibly with the untouched paper of the background. This delicate modeling in the head contrasts strikingly with the rough, seemingly crude handling of the lines and shading in the cloak and the hands.

After sketching the outlines lightly, Rembrandt quickly established the mass of the body by making a series of parallel shading marks, generally running diagonally from upper right to lower-left. Some of these shading marks are apparent in the drawing's lower-left corner and to the right of the model's left arm, where they serve to indicate cast shadows. In making these marks Rembrandt applied the chalk with restrained pressure, thus exploiting the grain of the paper and the tendency of the chalk (possibly a type of slightly waxy crayon) to catch on the "ridges" while leaving the "valleys" untouched. This gives the halftones an airy, atmospheric quality and was used with brilliant purpose to convey the effect of reflected light in the shadow on the right side of the head.

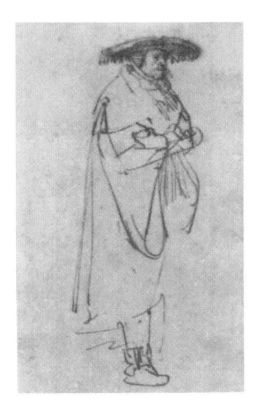

Man with Wide-Brimmed Hat
*1632-39, Ink on light-brown paper, 160 x 98 mm, Musees
Royaux des Beaux-Arts, Brussels*

The present drawing shows a man, drawn full length
and wrapped in a long, wide coat, like the one we also
see in Rembrandt's drawings of Pantalone, one
example of which is preserved in Hamburg, where he
also wears a floppy, broad-rimmed hat with ear-muffs.
Rembrandt probably studied the figure of Pantalone,
the merchant in the Italian Commedia dell'arte during
stage performances at the Amsterdam annual fairs. For
his drawings of the actor he also worked from earlier
sources such as the engravings of Jacques Callot.

The Brussels sketch dates from 1632-39 and belongs to a fairly extensive group of studies of individual figures, without any decor or landscape, produced with gallnut ink on light-brown tinted paper. These are picturesquely apparelled personages such as farmers, beggars, actors and Orientals with eye-catching head-dresses. Typical of these rapid sketches is the accuracy with which Rembrandt is able to capture the essence of a movement or an attitude in a few strongly posed strokes and accents. With thin, almost scratchy pen-strokes certain details are expressed in at times considerable detail - the man's eyebrows and cheekbones - whilst other parts, like his coat, are indicated in a highly summary fashion with broad lines, their effect heightened by the way in which the gallnut ink, which contained iron, has soaked into the paper. The suggestive power of these drawings, built up with fluid but carefully placed lines to form a strongly structured pattern, remains unequalled.

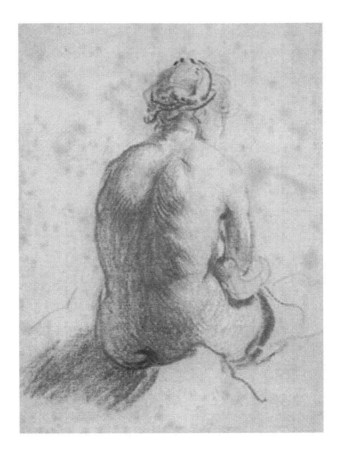

A Study of a Female Nude Seen from the Back
1630-1634, 16.5 x 11.8 cm, Coultard Institute Gallery, London

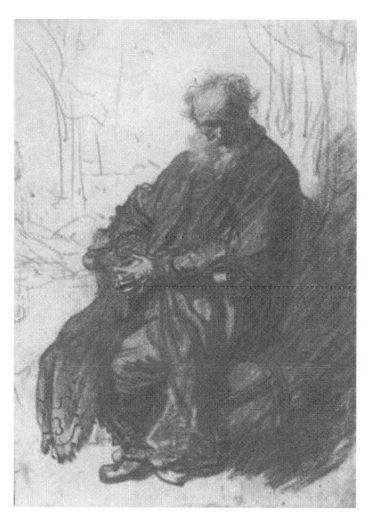

Old Man Seated in an Armchair, Full-length
1631, 226 x 157 mm, Kupferstichkabinett, Berlin

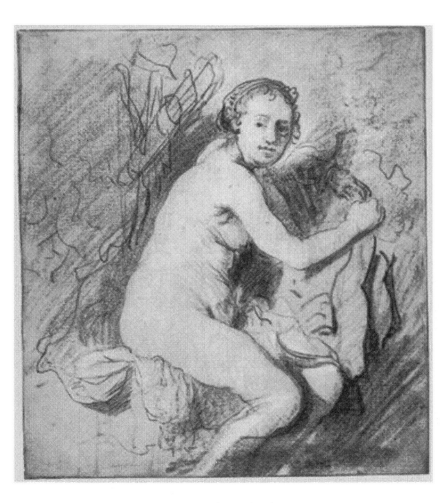

Diana at her Bath
1630-31, 181 x 164 mm, British Museum, London

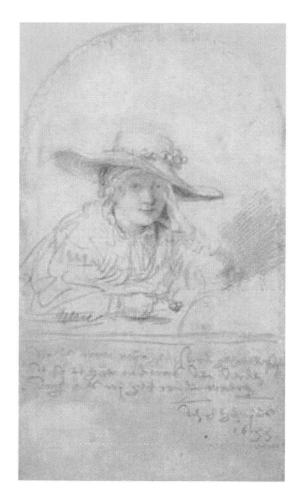

Saskia van Uylenburch

1633, 185 x 107 mm, Kupferstichkabinett, Berlin

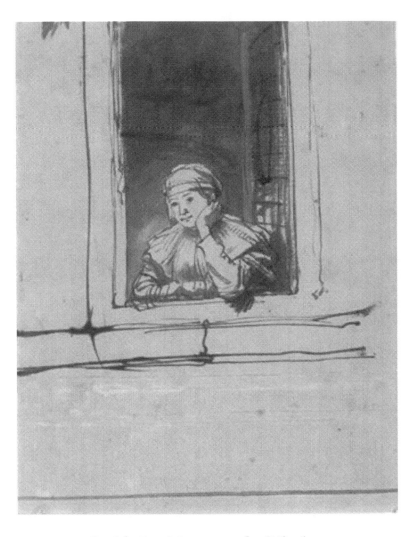

Saskia Looking out of a Window
1633-34, 236 x 178 mm, Boymans van Beuningen Museum,
Rotterdam

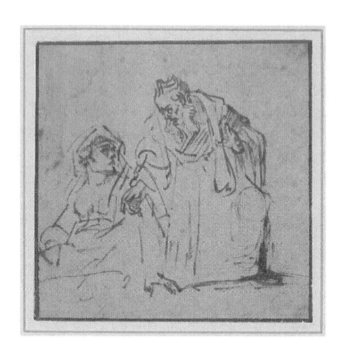

Study of a Man Talking to a Woman Seated on the Left
1635 - 1636, Pen and brown ink, Paul Getty Museum

Rembrandt communicated the emotional exchange between these two people with economy and force. He clearly demonstrated the man's stern admonishment as he turns to face the woman's darkened gaze. Concentrating on both faces and the man's hands--the carriers of the drama--Rembrandt used only a few calligraphic strokes to describe the pair's clothing and give them a sense of three-dimensionality. He also engaged the paper, making the blank areas as active in describing the scene as the lines themselves. Even in a rapid sketch, Rembrandt created a sense of narrative, drama, and character.

Rembrandt may have depicted an early event in the Old Testament story of the prophet Samuel. When Samuel's future mother Hannah moved her lips while silently praying to God to give her children, the high priest Eli reproached her, thinking she was drunk.

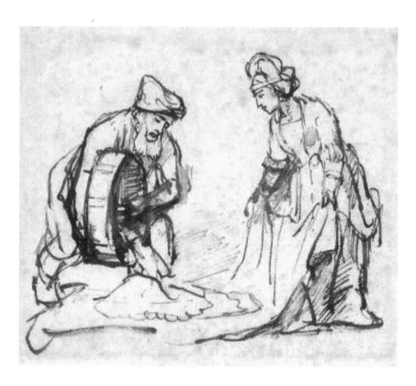

Boaz Casting Barley into Ruth's Veil
*c. 1645, Pen and brush, 126 x 143 mm, Rijksmuseum,
Amsterdam*

Boaz confirmed his promise to marry Ruth by casting
barley into her veil. Ruth, who had come to Canaan
with her mother-in-law Naomi, had gone out into Boaz'
fields to glean ears of corn, and had spent the night
lying at his feet. Rembrandt conveyed this scene from
the Book of Ruth with broad, contrasting strokes. He
omitted the background altogether - what mattered to
him were the figures and their expressions.

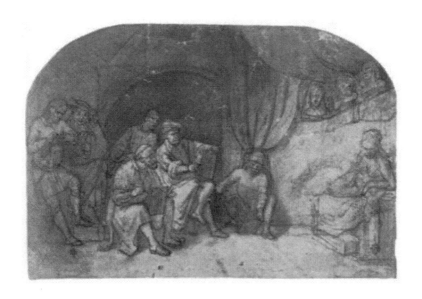

Drawing from the Nude Model in Rembrandt's Studio

1650s, Pen and brush in a brown wash over a chalk drawing, 180 x 266 mm, Hessisches Landesmuseum, Darmstadt

Working from the live model was an important part of Rembrandt's teaching method. One of his pupils recorded the entire drawing class in work.

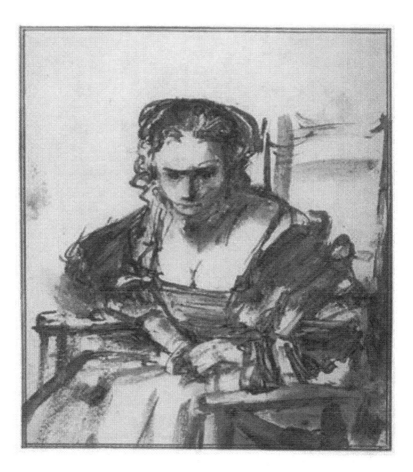

A Young Woman Seated in an Armchair
1654-60, 163 x 143 mm, British Museum, London

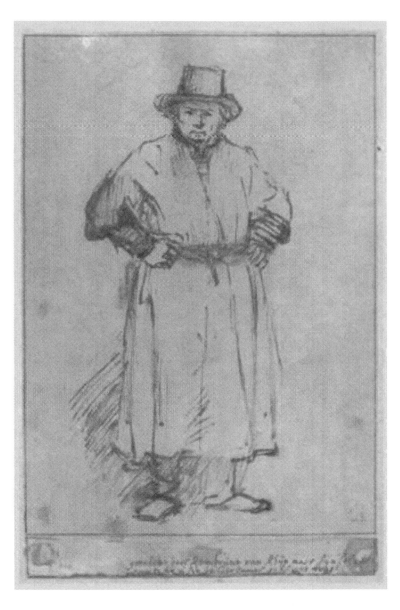

Self Portrait in Studio Attire, Full-length
1655, 203 x 134 mm, Rembrandt Huis, Amsterdam

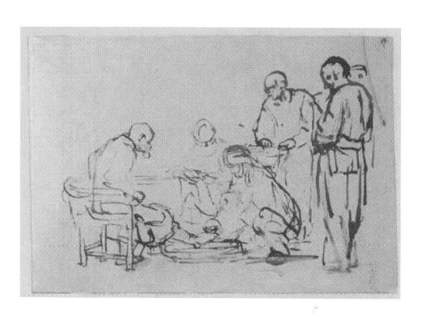

Christ Washing the Feet of his Disciples
1655, 157 x 221 mm, Rijksmuseum, Amsterdam

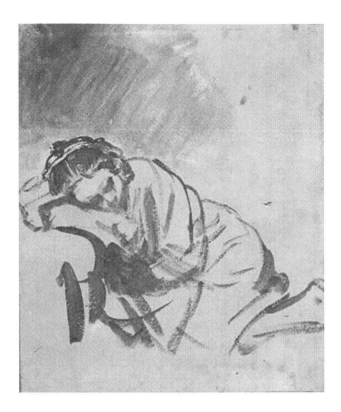

Woman Sleeping
1655, The British Museum, London

This is an unconventional type of portrait. It is both affectionate and yet not a precise likeness of the sitter. She can only be recognized in generalized terms as Hendrickje Stoffels (about 1626-63), Rembrandt's common-law wife. With the tip of the brush and only a few broad strokes he rapidly and skilfully outlined her sleeping body. He also used the white of the paper to create not just her form but also the atmosphere surrounding her. Above her head, a thin wash sets off her figure by suggesting the darkness of a corner of the room.

The drawing can be compared in style and appearance to Rembrandt's painting of Hendrickje, A Woman Bathing in a Stream (National Gallery, London). In the painting, dated 1654, she wears a similar, loose-fitting garment. She may have been pregnant, as in 1654 Hendrickje, who had entered the artist's household by 1649, gave birth to their daughter Cornelia. She died in 1663 and was buried in the Westerkerk, Amsterdam, where Rembrandt was buried six years later.

The study is drawn entirely with the brush in brown wash with some white bodycolour. This was an unusual technique for Rembrandt who mostly used pen or chalk in his drawings. It was both experimental for Rembrandt and is most appealing to the modern eye, and reminds us of oriental drawings made with the brush.

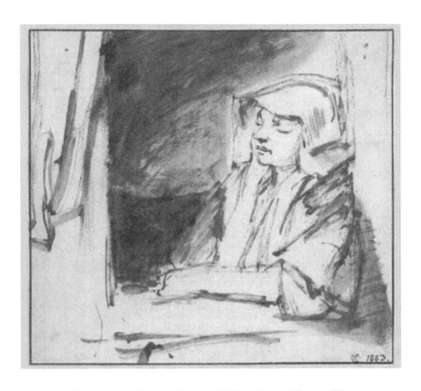

A Woman Seated at a Window, Eyes Shut
1655-1656, 16.3 x 17.5 cm, Nationalmuseum, Stockholm

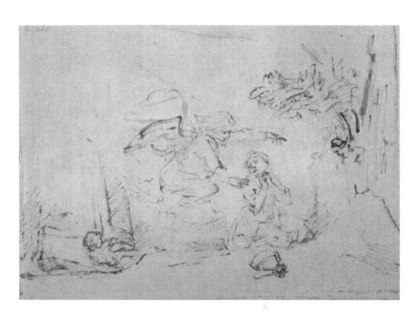

A Study for a Girl at a Window
1645, 8.8 x 6.6 cm, Courtauld Institute Gallery, London

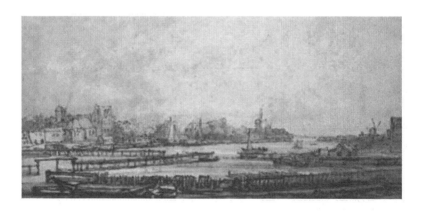

View over the Amstel over the Rampart
1647-50, 90 x 106 mm, Rosenwald Collection, National Gallery of Art, Washington D.C.

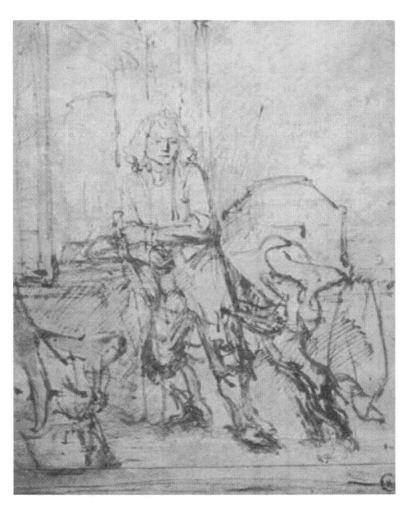

Jan Six with a Dog, Standing by an Open Window
1647, 220 x 175 mm, Private Collection

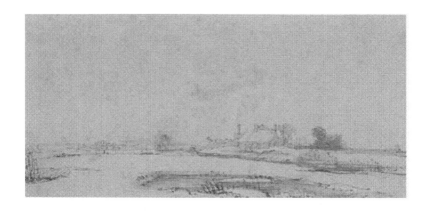

Landscape with a Farmstead
1649-1650, 7 x 15 cm, Chatsworth Settelemnt, Chatsworth

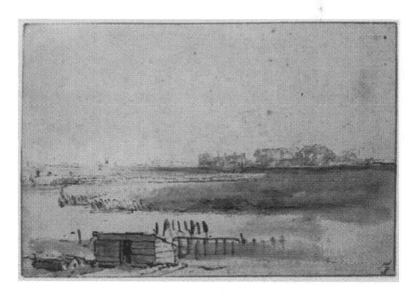

View of Houtewaal
1650, 125 x 182 mm, Chatsworth Settlement, Chatsworth

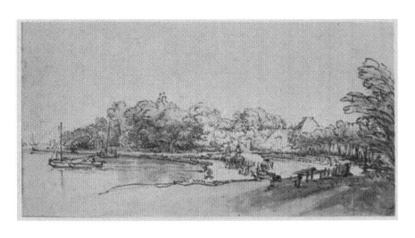

A Bend in the Amstel at Kostverloren
1650, 136 x 247 mm, The Duke of Devonshire and the
Trustees of the Chatsworth Settlement, Chatsworth

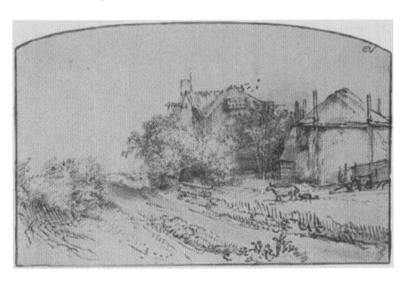

A Haystack near a Farm
1650, 128 x 200 mm, Chatsworth Settlement, Chatsworth

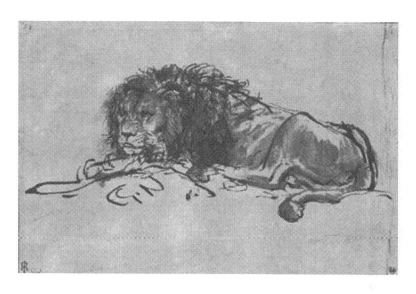

Lion Resting, Turned to the Left
1650-52, 138 x 204 mm, Louvre, Paris

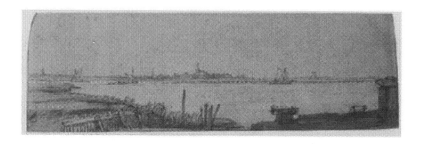

View over'Het Ij' from Diemerdijk
1650-1653, 76 x 244 mm, Chatsworth Settlement, Chatsworth

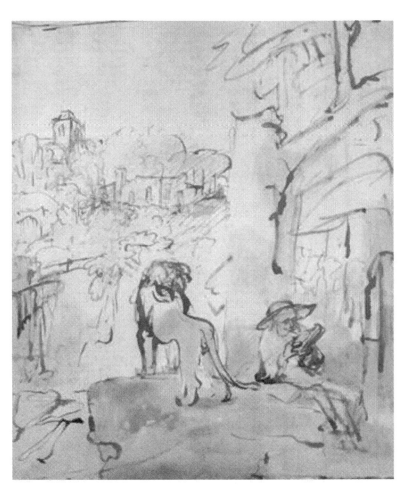

St. Jerome Reading in a Landscape
1652, 250 x 207 mm, Kunsthalle, Hamburg

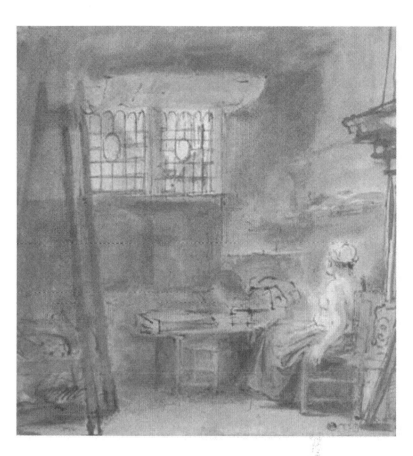

Rembrandt's Studio with a Model
1654, 206 x 191 mm, Ashmolean Museum, Oxford

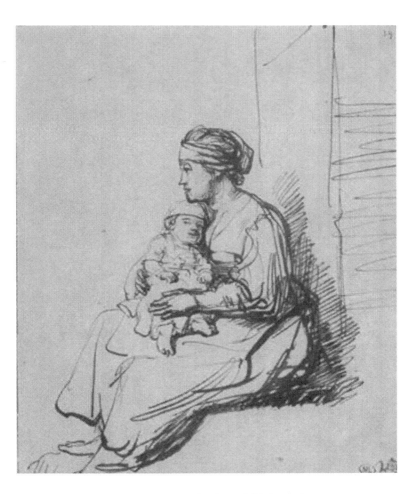

A Woman with a Little Child on her Lap
1635, 16 x 13.6 cm, Musée du Louvre, Paris

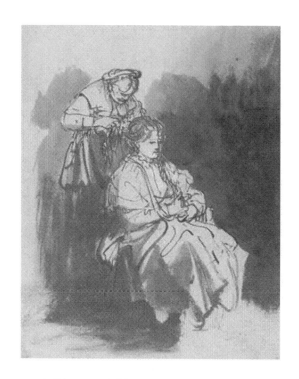

A Young Woman at Her Toilet
*ca. 1635, pen and brown ink, brush and brown and gray
inks, Albertina Museum, Vienna, Austria*

A Young Woman at Her Toilet is a pen-and-wash ink
drawing from the mid-1630s. The drawing was once
thought to be a study for a painting of a biblical
heroine, but it now seems more likely that, like most of
Rembrandt's drawings, it is a stand-alone creation,
done for pleasure and to practice his skills. The young
woman having her hair braided is probably
Rembrandt's wife, Saskia; the older woman standing
behind her could be a servant. Saskia was from a
wealthy family, and at this time Rembrandt enjoyed the
height of his commercial success as the most sought-
after portrait painter in Amsterdam.

Two Studies of a Baby with a Bottle
*1635, 101 x 124 mm, Staatliche Graphische Sammlung,
Munich*

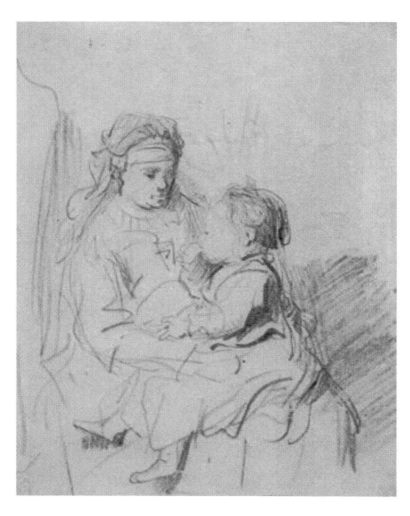

A Nurse and an Eating Child
1635, 16.5 x 13 cm, Albertina, Graphische Sammlung,
Vienna

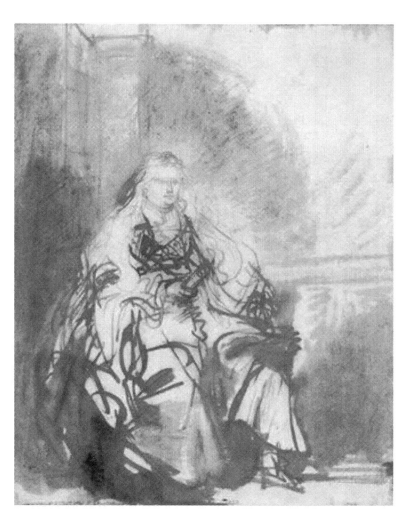

A Study for 'The Great Jewish Bride'
1635, 240 x 190 mm, Nationalmuseum, Stockholm

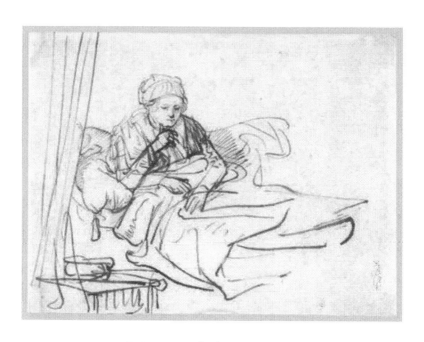

A Woman sitting up in Bed
1635, 14.8 x 19.1 cm, Grininger Museum, Groningen

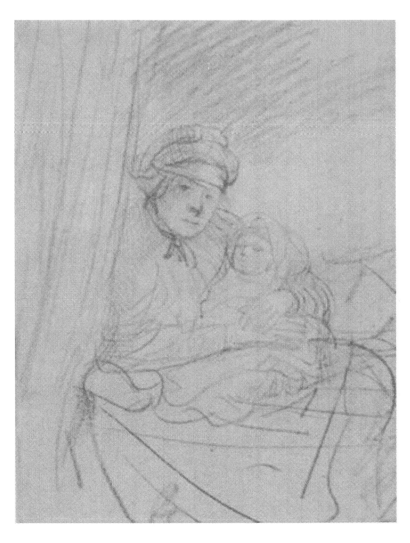

A Woman sitting up in a Bed
1635-1636, 14 x 14.6 cm, Coultard Institute Gallery, London

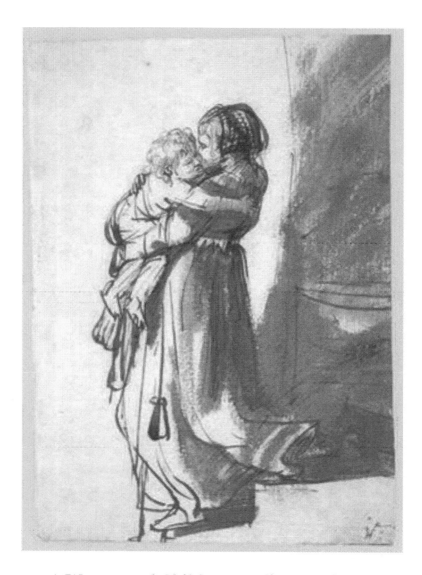

A Woman and Child Descending a Staircase
1625-1636, 18.7 x 13.2 cm, Pierpoint Morgan Library, New York

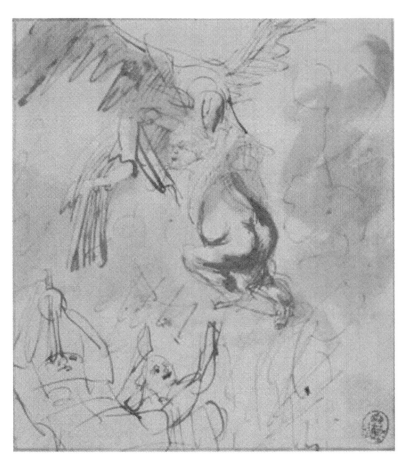

Ganymede Carried Away by the Eagle of Zeus
*1635, 183 x 160 mm, Kuperstich-Kabinett der Staatlichen,
Dresden*

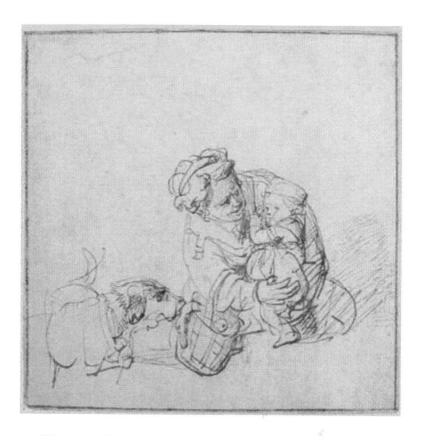

A Woman Comforting a Child Frightened by a Dog
1636, 10.3 x 10.2 cm, Collection Frits Lugt, Institut Néerlandais, Paris

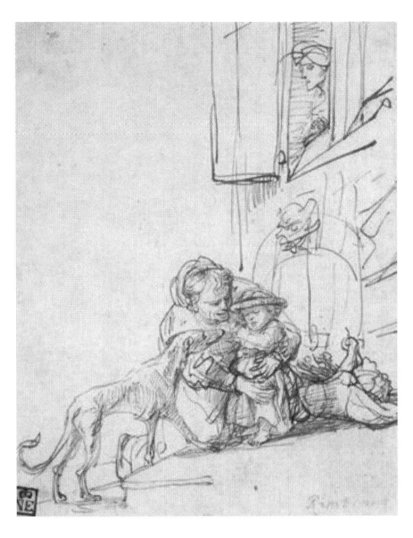

Woman with a Child Frightened by a Dog
1636, 18.4 x 14.6 cm, Szépmüvészeti Múzeum, Budapest

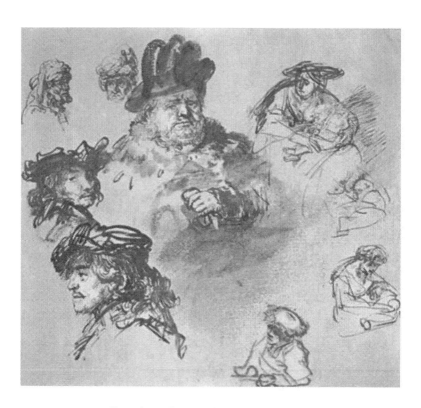

Study of Heads and Figures
*1636, Barber Institute of the Arts, University of
Birmingham, England*

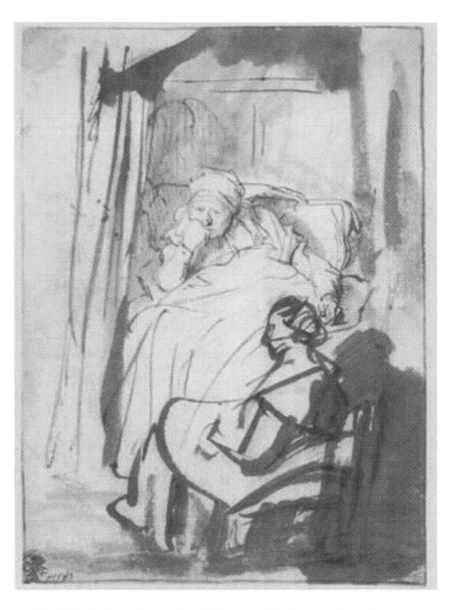

Saskia Lying in Bed, a Woman Sitting at her Feet
*1635-38, 228 x 165 mm, Staatliche Graphische Sammlung,
Munich*

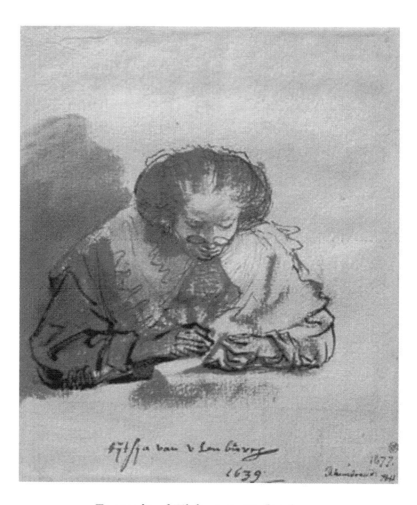

Portrait of Titia van Uylenburg
1639, 17.4 x 14.6 cm, National Museum, Stolkholm

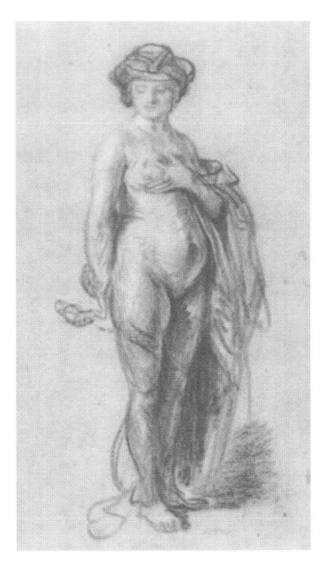

Nude Woman with a Snake
1636, 24.7 x 13.7 cm, Paul Getty Museum, Los Angeles

This woman stands nude, squeezing her breast with one hand while holding a large snake behind her with her other hand. The snake, the headdress, and her bared breast suggest that Rembrandt meant to depict Cleopatra, although recent scholars have suggested that the figure has certain aspects of Eve. In fact, Rembrandt used this drawing as the basis for his depiction of Eve in his drawing and subsequent etching Adam and Eve of 1638.

Rembrandt applied red chalk energetically, describing the swell of the woman's belly with strong horizontal strokes. Vertical shading along her legs conveys her body's taut strength. He also exploited the brilliance and luminosity of the red chalk by applying white gouache underneath it, particularly in the woman's arm and torso. The glowing quality of the red chalk with white underneath and the solid three-dimensionality of form create a sense of energy radiating from her.

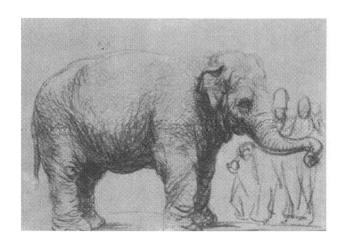

An Elephant, in the Background a Group of Spectators
1637, *The British Museum, London*

This is one of several drawings by Rembrandt of
female elephants in different poses. This elephant may
even be one called 'Hansken', a female despite her
name, known to have been in Holland in 1641. Behind
and to the right of the animal are the outlines of three
figures, perhaps a family with a child.
 The drawing, in black chalk and charcoal, shows a
clear mastery of form and technique. Most of the
animal is outlined with a long thin line. Rembrandt
used black chalk in short broken strokes to convey the
texture of the elephant's rough wrinkled skin, the
ragged ear and curling trunk. In the darkest shadows of
the ear and neck he used charcoal to reinforce their
depth, an unusual technique for the artist. The
elephant's trunk and the family have a broader outline.

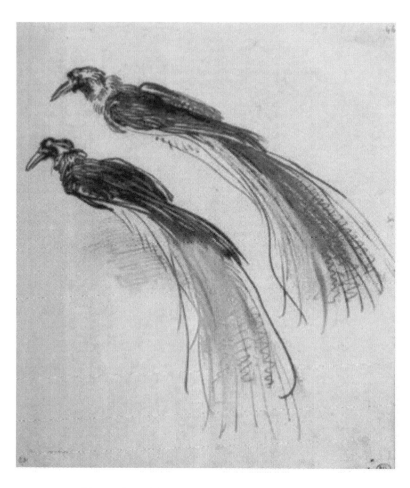

Two Studies of a Bird of Paradise
1637, 181 x 154 mm, Louvre, Paris

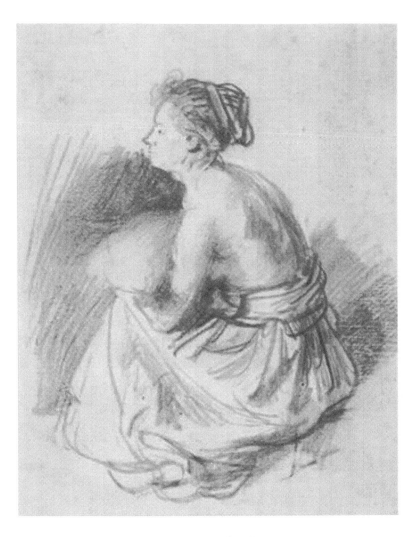

A Seated Woman, Naked to the Waste

*1637, 19.9 x 15.3 cm, Boijmans van Beuningen Museum,
Rotterdam*

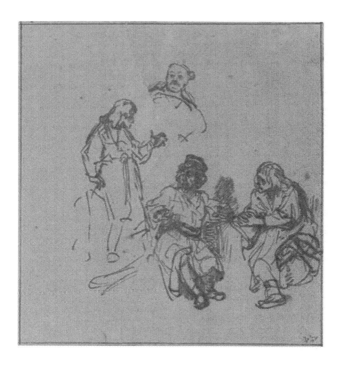

Joseph in Prison Interpreting the Dreams of Pharoah's Baker and Butler
1639, Pen and brown ink on light brown prepared paper; the figure of Joseph is on a separate, irregularly cut sheet, Paul Getty Museum

While imprisoned, Joseph, shown here standing to the left, interpreted the dreams of the Pharoah's butler and baker, also thrown into jail for offending their master. Rembrandt conveyed the moment when the baker, in a flat cap, discovers that Pharaoh will have him hanged in three days. The butler, who learns that he will be restored to his position, leans forward, hands clasped, listening intently. Joseph's predictions for these two came true, and his interpretation of Pharaoh's dream saved all of Egypt two years later.

As with most of his compositional studies of religious subjects, Rembrandt probably made this drawing not as a preparatory study for a project but for its own sake. His working methods were highly experimental; he himself may have joined together the two sheets of paper that comprise this drawing. On one sheet he developed detailed studies of the butler and baker; on the other he captured Joseph with the fewest pen marks possible. Rembrandt used iron-gall ink, originally black but now faded to brown.

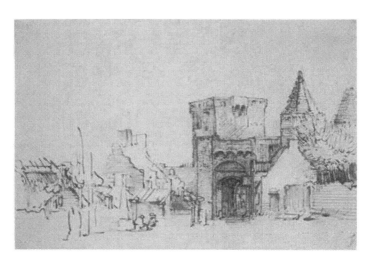

The Rijnspoort at Rhenen
1640, 120 x 176 mm, Chatsworth Collection, Chatsworth

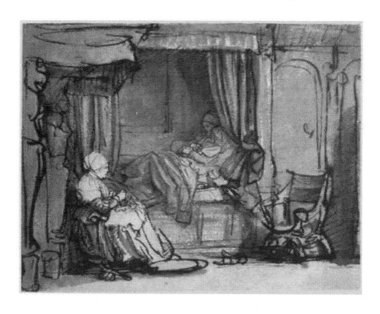

An Interior with a Woman in Bed
1640-1641, 14.1 x 17.6 cm, Collectiom Frits Lugt, Istitut
Néerlandais, Paris

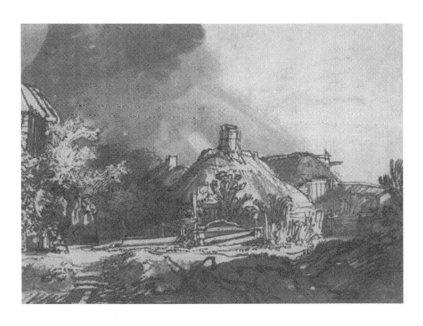

A Bend in the Amstel at Kostverloren
*1640, 136 x 247 mm, The Duke of Devonshire and the
Trustees of the Chatsworth Settlement, Chatsworth*

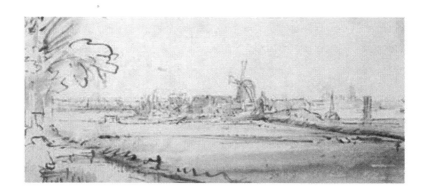

Open Landscape with Houses and a Windmill (The Former Copper Mill on the Weesperzijde)
1640, Albertina Museum,Vienna, Austria

Turning to a landscape drawing from the 1640s, Open Landscape With Houses and a Windmill (The Former Copper Mill on the Weesperzijde), we experience Rembrandt's handling of pen-and-brush at its most exquisite. The drawing was done on location, as were hundreds of others with which he filled his sketchbooks during his walks about the environs of Amsterdam. The motif is conventional — a repoussoir tree on the left anchors the composition, and the center of interest in the middle distance is sandwiched between a dark foreground and a broad expanse of sky. The artist has transformed this formula into a complex drama of manifold spatial tensions and quirky mark-making, and yet manages to convey a convincing illusion of light-saturated atmosphere.

The washes in this drawing vary from soft and delicate, as in the distant spatial planes of the buildings on the skyline at the right, to rough and textural, made by dragging a half-dry brush across the paper on the lower right. Rembrandt created an especially delicious effect on the left using a combination of a few penned lines and dots with a lightly dragged wash to reproduce the complex textures of foliage and buildings shimmering in moist, hazy air.

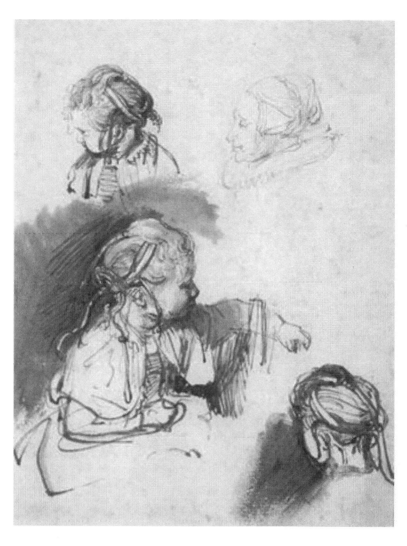

Three Studies of a Child, One Study of a Woman
*1640-1645, 21.4 x 16 cm, Fogg Art Museum, Harvard
University Art Museums, Cambridge*

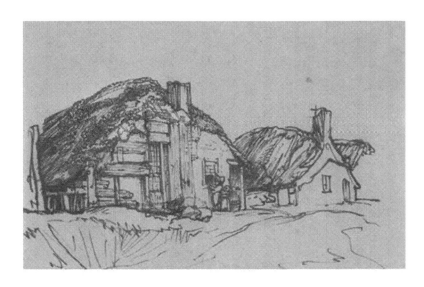

Two Thatched Cottages with Figures at a Window
*1640, Pen and brown ink, corrected with white bodycolor,
Paul Getty Museum*

Around 1640, Rembrandt made five drawings, similar in setting and technique, of these two thatched cottages. Unlike most of his landscapes, this drawing almost entirely eschews atmospheric effects in favor of building up monumental architectural and textural forms with bold strokes of the quill pen. The larger house's monumentality and detail contrasts with the cursory jottings that compose the neighboring house and the few squiggly lines that indicate the earth.

As always, Rembrandt drew only what was essential. His animated line moved vigorously across the sheet, creating rich and varied effects of texture and surface. At this point in his career, Rembrandt delighted in exploring the visual impact of varied, dense lines, as seen in the moss growing in the thatched roof of the nearest house. Rembrandt's bold quill pen work here brings to mind the work of Vincent van Gogh two-and-a-half centuries later.

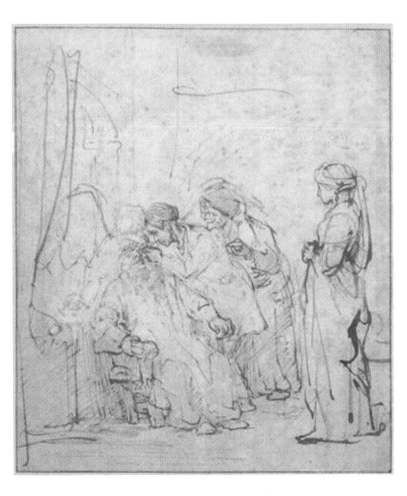

The Healing of Tobit
1640-1645, 210 x 177 mm, Private Collection

**Woman Wearing a Costume of Northern Holland,
Seen from her Back**
1642, 220 x 150 mm, Teyler Museum, Haarlem

Three Women and a Child
1645, 23.2 x 17.8 cm, Rijksmuseum, Amsterdam

The Bend in the Amstel
1650, 145 x 213 mm, The British Museum, London

This scenic location on the Amstel River atKostverloren House is situated a few miles south of central Amsterdam. It was a favourite haunt of seventeenth-century Dutch artists. Rembrandt drew it at least six times.

Here he has used a reed pen with brown ink and brown wash. Some white heightening is visible on the gable of the house at far right. The paper itself was prepared with a light brown wash thinly applied in broad strokes. The brown washes of the drawing stand out particularly well against this paper colour. The darker washes are in the foreground around the dug-out, strongly shaded by the tree on the right. Paler wash with parallel hatching colours the bank of trees in the background to suggest the depth of the scene. Over the top of the trees appears the tower of the house. On the left are the outlines of a building and a boat on the river.

It may be that in using prepared paper and creating a balanced composition, Rembrandt regarded the drawing as a finished work of art in its own right. The varied depths of the shadows and details of the foliage are so vivid they may have been sketched from first-hand observation, although it is uncertain whether it was made out-of-doors.

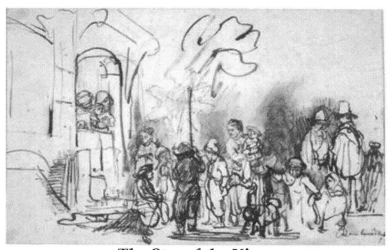

The Star of the Kings
1645-47, 204 x 323 mm, The British Museum, London

This drawing, in pen and brown ink, depicts a
Netherlandish custom in celebration of the Christian
feast of Epiphany (6 January), the commemoration of
the visit of the three Kings to the newborn Christ.
Children went from door to door carrying a lantern
shaped like a star (the 'Star of the Kings'). They asked
for money from the occupants of the houses.
 Rembrandt may have drawn this scene from life. To
the left of the central group a family watches from the
front of a house. The architecture is barely shown in the
fluid lines of the ink. A mother with a basket and baby
in her arms observe the group of children. Outside the
main group, another child points to the star and pulls a
smaller child who is clearly frightened and crying. In
the front, in broad pen strokes, two dogs sniff at each
other in greeting. Two men stare from the right, with
another in the background.

Both the brown wash and parallel hatching provide the shading necessary to suggest depth and the nocturnal atmosphere. The men at right stand against dark shadows while the back of the boy holding the star lantern is entirely seen in shadow. The lantern illuminates the unseen front of the boy and the rest of the group.

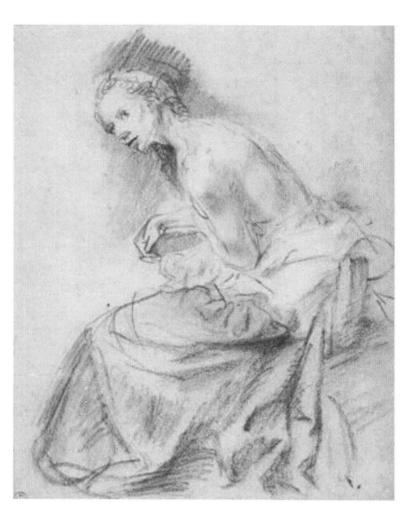

A Seated Female Nude as Susanna
1647, 20.3 x 16.4 cm, Kupperstichkabinett, Staatliche Museen, Preussischer, Kulturbesitz, Berlin

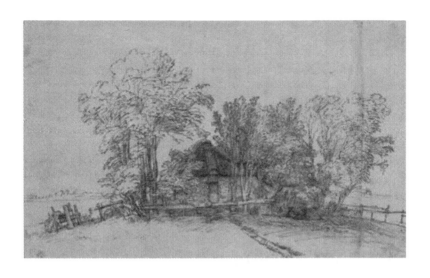

Cottage among Trees
1648–50, Pen and brown ink, brush and brown wash, on paper washed with brown, 17.1 x 27.6 cm, The Metropolitan Museum of Art

Among Rembrandt's sketches of rustic farmhouses and cottages, this drawing is unusually finished in execution and formal in composition. Rembrandt drew the scene with fine pen lines of fairly even width. He applied wash sparingly and rendered the texture of the thatch roof with heavily inked strokes reminiscent of a drypoint burr. In so doing, he created a work related in feeling to his etchings. Rembrandt situated the cottage parallel to the picture plane and framed it symmetrically by adding at the right of the original sheet a strip of paper, on which he extended the tree branches, the fences, and the distant horizon. In its reinterpretation of Italian Renaissance principles of composition, this drawing reveals parallels with paintings Rembrandt made in the years 1648–50, most notably the Supper at Emmaus of 1648 (Louvre, Paris).

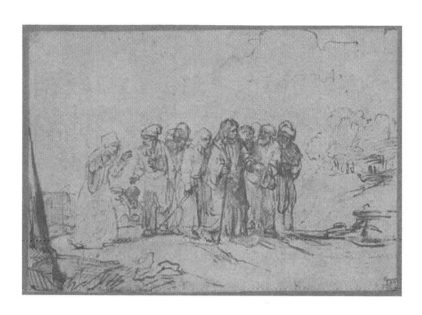

Christom and the Canaanite Woman

1650, Pen and brown ink, brown wash, corrected with white bodycolor, Paul Getty Museum

Moments after the apostles turned away the Canaanite woman; Christ listened to her demonstration of faith and healed her daughter of demonic possession. The two areas of focus in this drawing correspond to these two main characters, as yet separated - Christ in the center and the Canaanite woman in an exchange with an apostle at the left. The onlookers behind and beneath the woman and the indeterminate projection at the left add depth and foreground to the scene.

Modeling his figures with fine hatching, Rembrandt displayed a wide variety in the width and character of his lines. Correcting and altering the composition as he worked, he partially blotted out one of the onlookers' faces and covered Christ's left hand and foot with white bodycolor. The lightly sketched landscape at the right typifies Rembrandt's characteristic use of space and light, easily suggested with ink alone. In the 1640s, Rembrandt preferred to draw directly with pen and ink, unlike most of his contemporaries, who began their drawings with preliminary pencil or chalk sketches, then covered over those lines with ink.

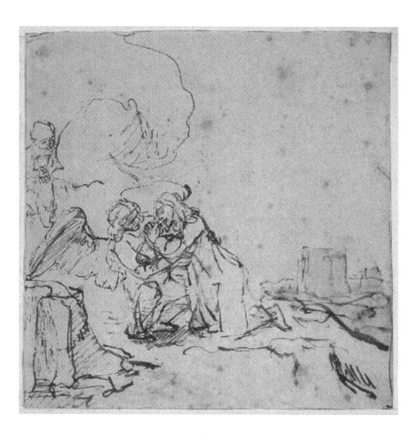

The Agony in the Garden
1648-1655, pen and brown ink, brown wash, on paper, 196 x 190 mm, Fitzwilliam Museum.Cambridge

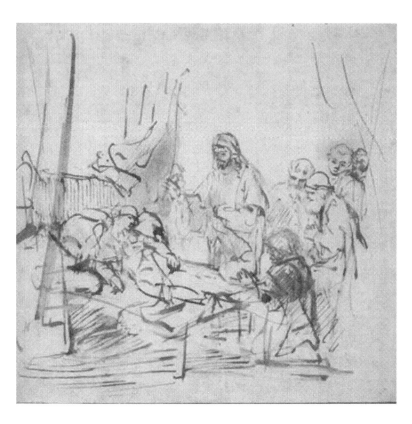

The Rasing of the Daughter Jarius
1655-1660, 198 x 198 mm, Kupfenstichkabinet, Berlin

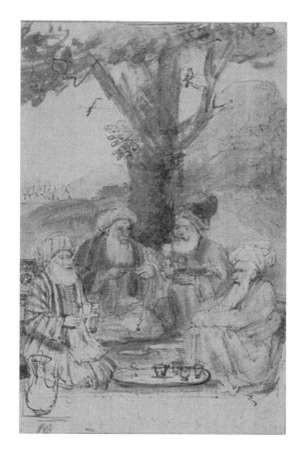

Four Orientals seated under a tree
1656, 193 x 124 mm, The British Museum, London

This unusual scene is one of a series of drawings that
Rembrandt freely based on seventeenth- century
Mughal miniatures from India. It is likely that
Rembrandt studied these figures because he was
fascinated by their costumes. In many of his paintings
and self-portraits, his love of costumes and elaborate
hats or turbans is evident. Here he concentrates on the
textiles and turbans.

The miniature that formed the basis for this drawing is probably that in the Nationalbibliothek, Vienna. It is interesting is that some of the delicacy of the original miniature, notably in the faces, has been transferred by Rembrandt to his own freely drawn version. This drawing is thought to date from after 1656 when Rembrandt made an etching of Abraham and the angels which was inspired by the design copied here.

The drawing has been made on oriental paper that has been prepared with a pale brown wash. The figures are drawn in pen and brown ink with brown and grey wash. Some parts have been heightened with white with some areas scraped out. The tree is freely drawn in wash with the birds and few leaves sketchily added in pen and ink.

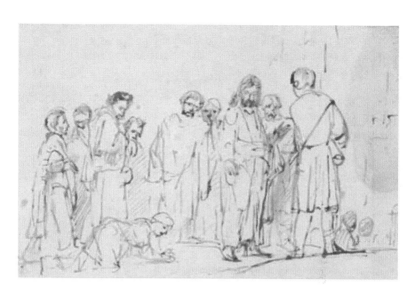

Christic with His Disciples and the Bleeding Woman
*ca. 1658, pen and brown ink, Albertina Museum, Vienna,
Austria*

By the mid-1650s the reed pen had become
Rembrandt's preferred drawing instrument. Christ
with His Disciples and the Bleeding Woman is a reed-
pen drawing that shows Rembrandt's shorthand style
in its final phase. In contrast to his landscapes of the
middle period, where he was concerned with rendering
a sense of spatial recession and atmosphere, in his later
drawings he ignored spatial effects in favor of a
classical monumentality built of simple tectonic forms.
The subject of this drawing is one of Christ's miracles,
as described in Luke 8:40 — the healing of the bleeding
woman. She secretly approaches Christ in a crowd and
touches his robe, which instantly stops the bleeding.
When Jesus notices this she falls down and tells him
what she has done; Christ then tells her that her faith
has cured her.

Rembrandt has chosen to depict the story's emotional climax. The scene is portrayed as if on a stage or as a sculptural relief. The standing figures form a frieze, their heads all at generally the same level, while the prostrate woman's head is at the bottom, on a level with two indistinct ovals at the lower right. The figures are mere gesture drawings — each one was probably drawn in a minute or less. And yet the formal unity of the composition as well as the variety of expressions captured — the skepticism, curiosity, and shock of the disciples, the compassion of Christ, and the deep humility of the woman — are astonishing.

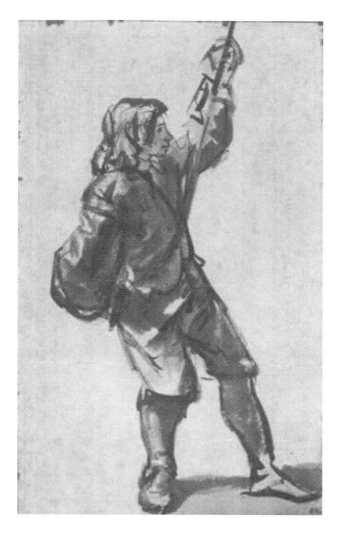

Life Study of a Youth Pulling a Rope
1656-58, 290 x 178 mm, Rijksprentenkabinet, Amsterdam

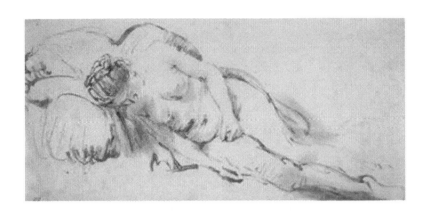

A Nude Woman Lying on a Pillow
1658, 13.5 x 28.3 cm, Rijksmuseum, Amsterdam

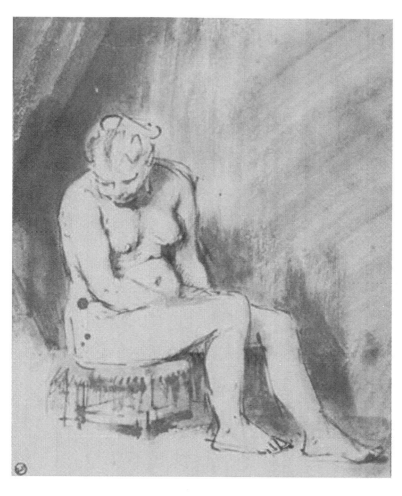

Seated Female Nude
1660, 21.1 x 17.4 cm, Art Institute of Chicago, Chicago

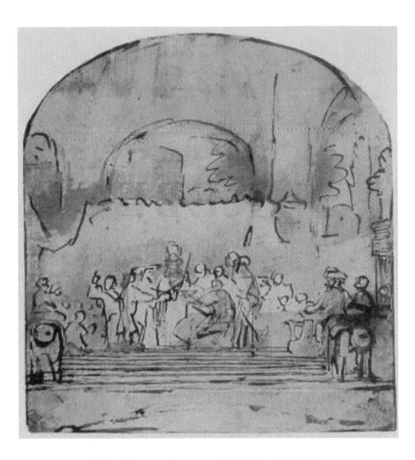

The Conspiracy of Julius Civilis
1661, 196 x 180 mm, Staaliche Graphihische Sammlung,
Munich

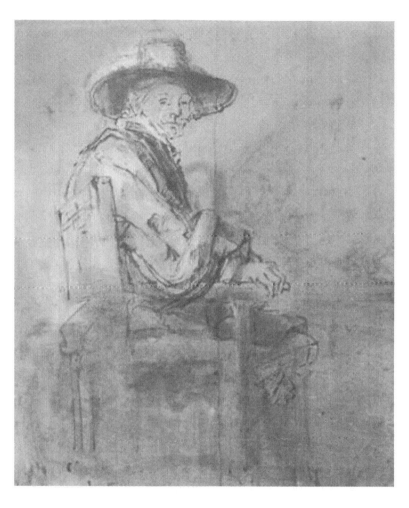

Study of a Syndic
1662, 193 x 159 mm, Rijksmuseum, Amsterdam

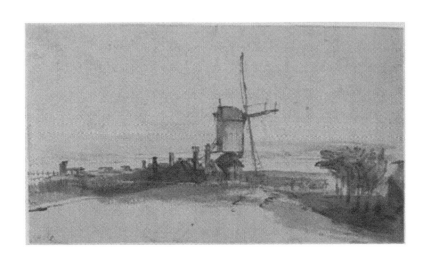

The Mill on the 'Het Blauwhoofd'
1654, 145 x 115 mm, Prins Hendryk Lubomirski,
Lubomirski Museum, Lwow

Etchings

Rembrandt produced many of his works in this fashionable town house in Amsterdam (above left). Purchased by the artist in 1639, when he was 33, it proved to be the scene of personal tragedy: his wife and three of his children died here. The house became a financial burden, and in 1660 Rembrandt was forced to move. A new owner added the upper story and roof, giving it the appearance it still bears. In 1911 the Dutch movement made it a

Rembrandt produced etchings for most of his career, from 1626 to 1660, when he was forced to sell his printing-press and virtually abandoned etching. Only the troubled year of 1649 produced no dated work. He took easily to etching and, though he also learned to use a burin and partly engraved many plates, the freedom of etching technique was fundamental to his work. He was very closely involved in the whole process of printmaking, and must have printed at least early examples of his etchings himself.

At first he used a style based on drawing, but soon moved to one based on painting, using a mass of lines and numerous bitings with the acid to achieve different strengths of line. Towards the end of the 1630s, he reacted against this manner and moved to a simpler style, with fewer bitings. He worked on the so-called Hundred Guilder Print in stages throughout the 1640s, and it was the "critical work in the middle of his career", from which his final etching style began to emerge.

Although the print only survives in two states, the first very rare, evidence of much reworking can be seen underneath the final print and many drawings survive for elements of it. In the mature works of the 1650s, Rembrandt was more ready to improvise on the plate and large prints typically survive in several states, up to eleven, often radically changed. He now uses hatching to create his dark areas, which often take up much of the plate. He also experimented with the effects of printing on different kinds of paper, including Japanese paper, which he used frequently, and on vellum. He began to use "surface tone," leaving a thin film of ink on parts of the plate instead of wiping it completely clean to print each impression. He made more use of drypoint, exploiting, especially in landscapes, the rich fuzzy burr that this technique gives to the first few impressions.

His prints have similar subjects to his paintings, although the twenty-seven self-portraits are relatively more common, and portraits of other people less so. There are forty-six landscapes, mostly small, which largely set the course for the graphic treatment of landscape until the end of the 19th century. One third of his etchings are of religious subjects, many treated with a homely simplicity, whilst others are his most monumental prints. A few erotic, or just obscene, compositions have no equivalent in his paintings. He owned, until forced to sell it, a magnificent collection of prints by other artists, and many borrowings and influences in his work can be traced to artists as diverse as Mantegna, Raphael, Hercules Segers, and Giovanni Benedetto Castiglione.

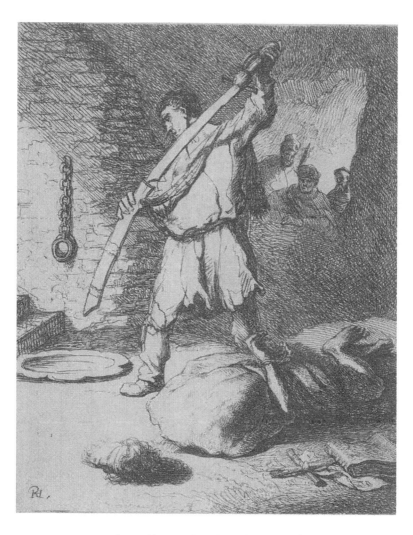

Beheading of John the Baptist
c. 1627

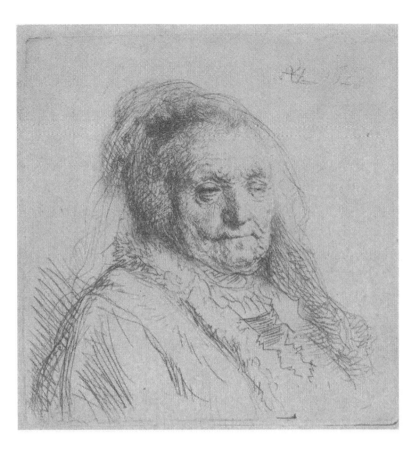

The Artist's Mother, Head and Bust
1628, 6.7 x 6.4 cm

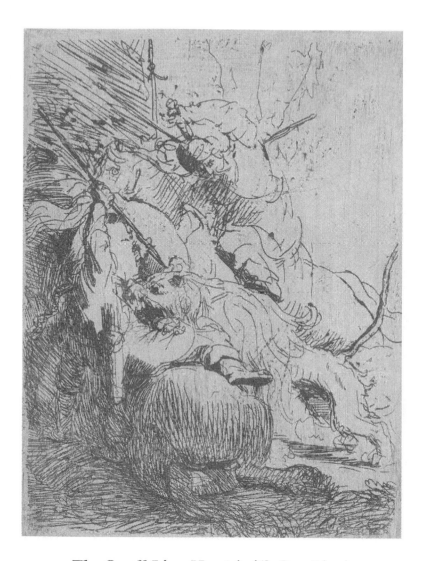

The Small Lion Hunt (with One Lion)
c. 1629, 16 x 11.8 cm

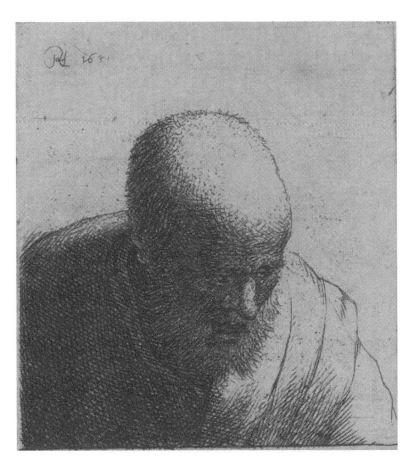

Bald Man with Open Mouth, Looking Down
c. 1630

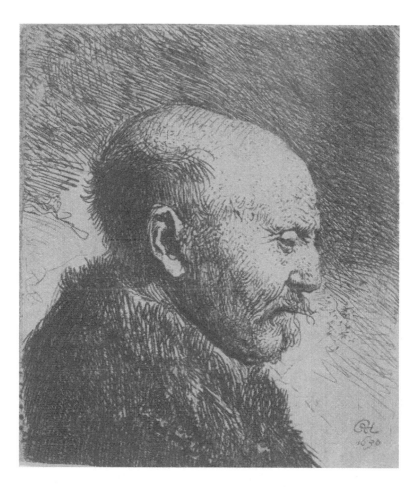

A Bald Man in Profile (The Artist's Father)
1630, etching on laid paper, 6.7 x 5.7 cm

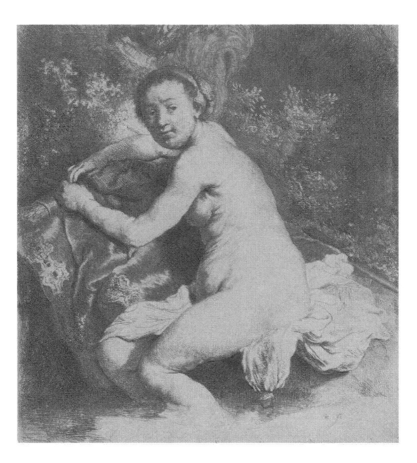

Diana at the Bath
c. 1631

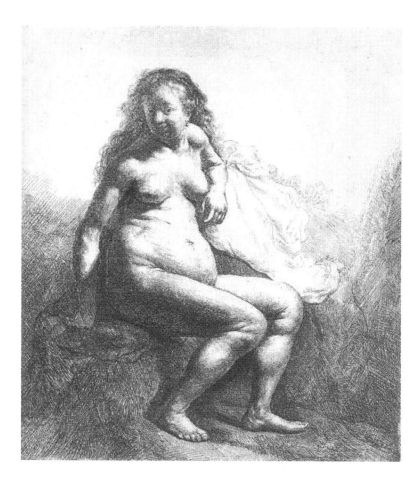

Seated Female Nude
c. 1631, 177 x 160 mm

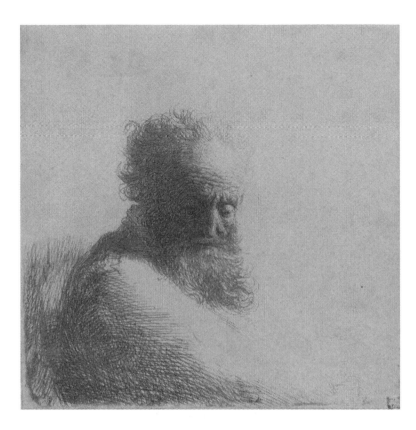

Bust of an Old Bearded Man, Looking Down, Three Quarters Right
1631, 11.1 x 11 cm

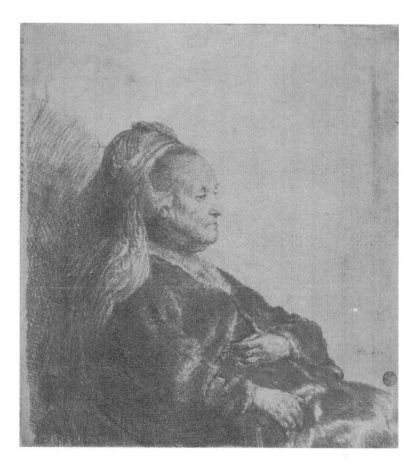

The Artist's Mother Seated, in an Oriental Headdress
1631

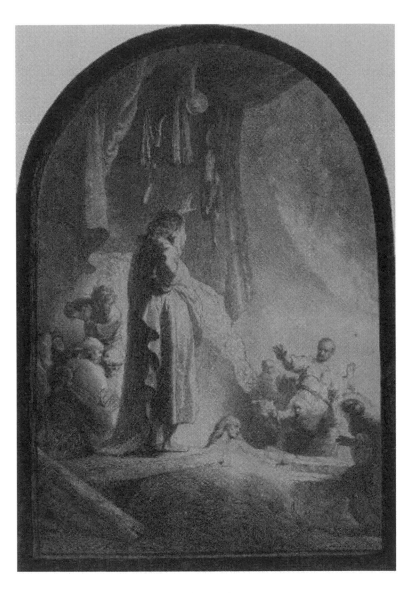

The Raising of Lazarus
c. 1632, 368 x 258 mm

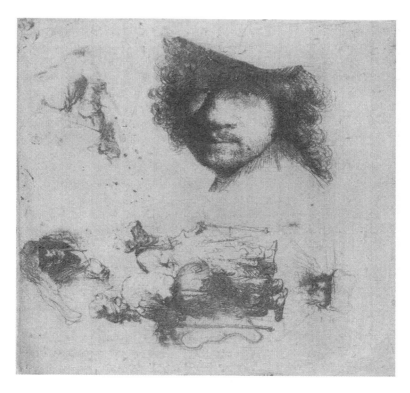

**Sheet of Studies including Head of the Artist, a
Beggar Couple, Heads of an Old Man a**
c. 1632, 9.9 x 10.5 cm

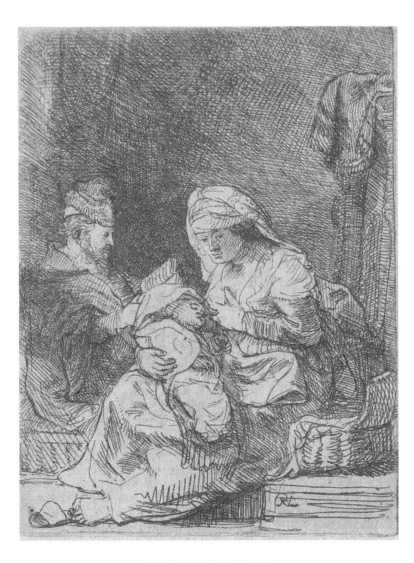

The Holy Family
c. 1632, etching on laid paper, 9.5 x 7.2 cm

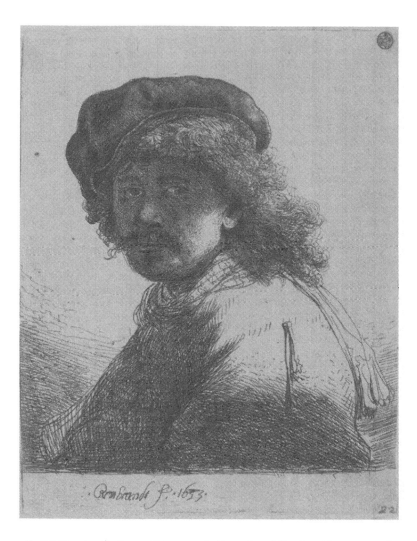

Self-Portrait in a Cap and Scarf with the Face Dark
1633, 13.6 x 10.7 cm

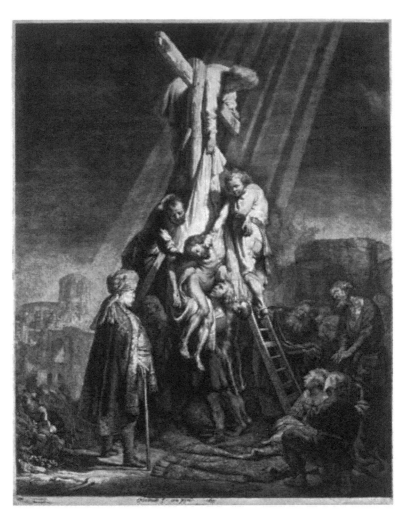

The Descent from the Cross
1633, Etching and burin, 530 x 410 mm

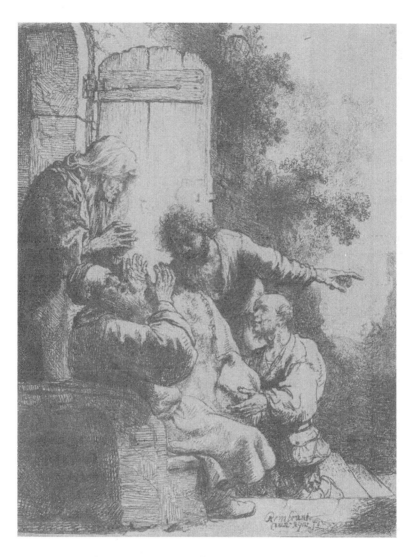

Joseph's Coat Brought to Jacob
c. 1633, etching and touches of drypoint

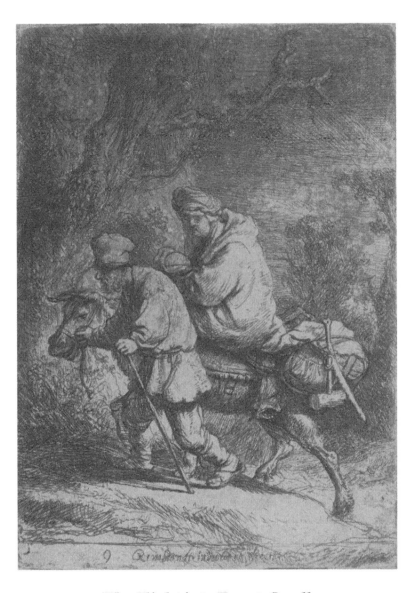

The Flight into Egypt: Small
1633, 9.2 x 6.5 cm

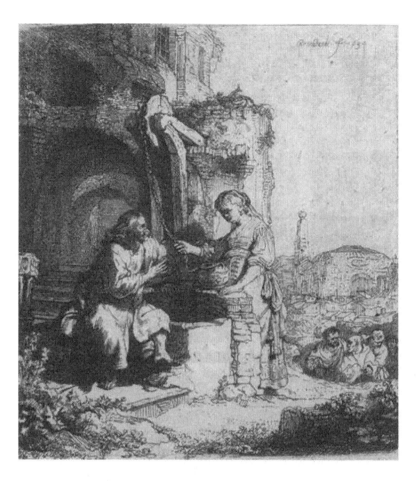

Christ and the Woman of Samaria
1634, 121 x 108 mm

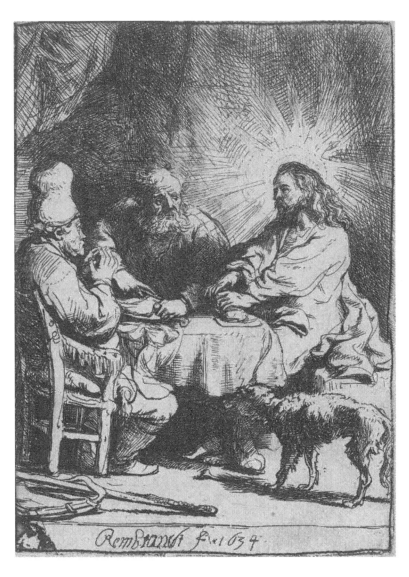

Christ at Emmaus: the Smaller Plate
1634

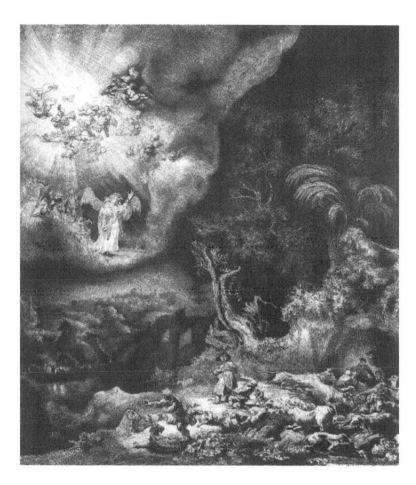

The Angel Appearing to the Sheperds
1634, Etching, burin, and drypoint, 261 x 218 mm

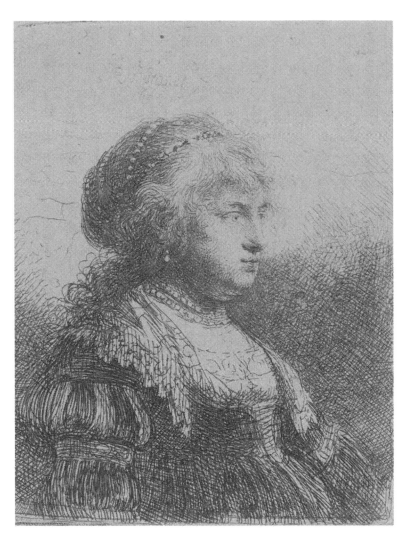

Saskia with Pearls in Her Hair
1634

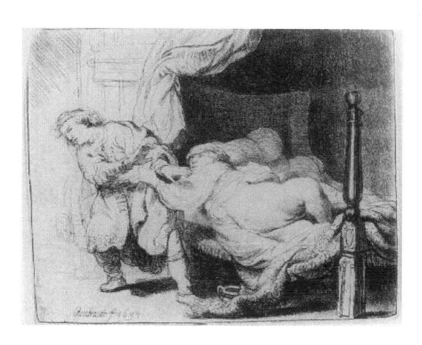

Joseph and Potiphar's Wife
1634, 90 x 115 mm

Joseph was the elder son of the Hebrew patriarch Jacob
and of Rachel. His numerous older brothers were
strictly only half-brothers, being the sons of Leah or of
handmaidens. The events of his romantic life story
have been depicted continuously in Christian art from
the 6th century onwards. The medieval Church saw the
episodes of his life as a prefiguration of the life of
Christ, and it is to this that he owes his important place
in Christian art.

When in Egypt as a slave, Potiphar, captain of the Pharaoh's guard, bought Joseph from the Ishmaelites and made him steward of his household (Gen. 39:7-20). Potiphar's wife 'cast her eyes over him and said, "Come and lie with me."' He refused her though she continued to press him. One day when they were alone together she clutched his robes, pleading with him to make love to her. At this, Joseph fled so precipitately that he left his cloak at her hands. When Potiphar came home she avenged her humiliation by accusing Joseph of trying to violate her, using the cloak as evidence. Joseph was promptly thrown into prison.

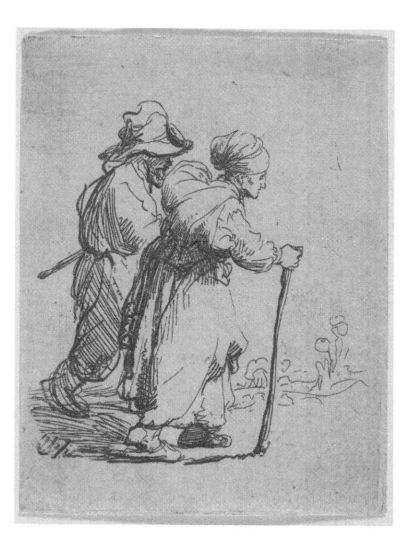

A Peasant Family Walking
c. 1634, 6.2 x 4.8 cm

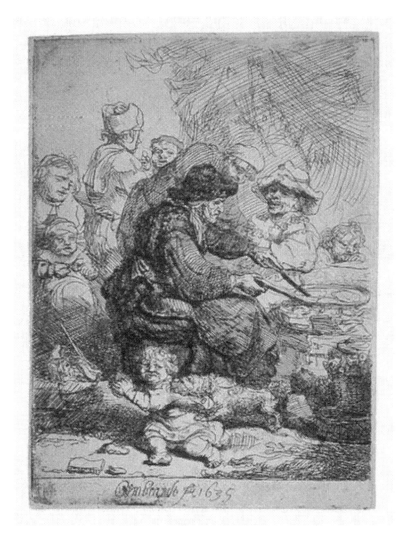

The Pancake Woman
1635, 109 x 77 mm

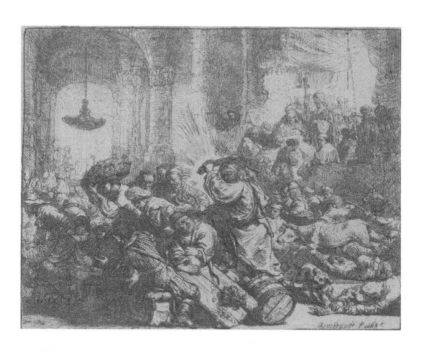

Christ Driving the Money Changers from the Temple
1635

The First Oriental Head
1635

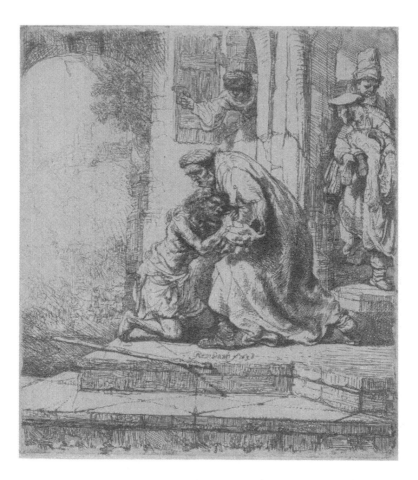

The Return of the Prodigal Son
1636, 156 x 136 mm

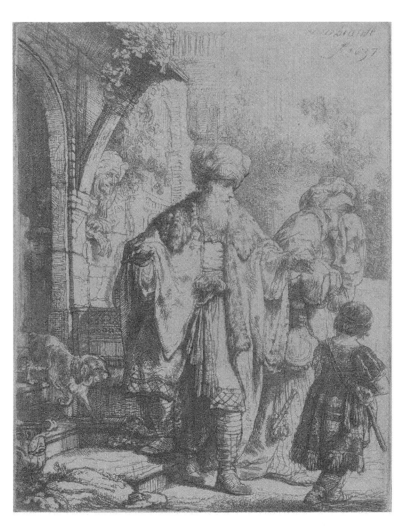

Abraham Dismissing Hagar and Ishmael
1637, Etching and drypoint, only state, 126 x 96 mm

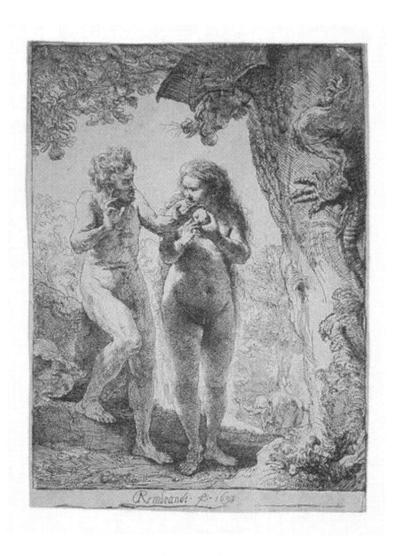

Adam and Eve
1638, 16.3x11.5 cm

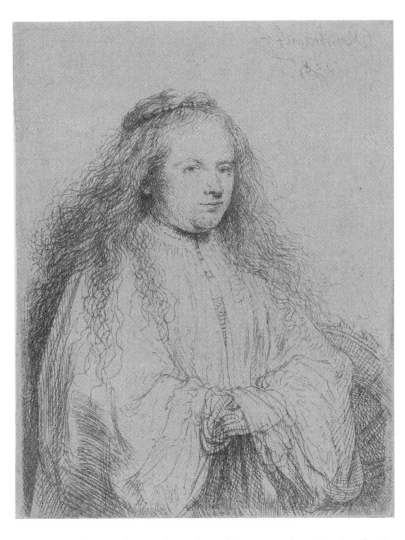

The Little Jewish Bride (Saskia as Saint Catherine)
1638

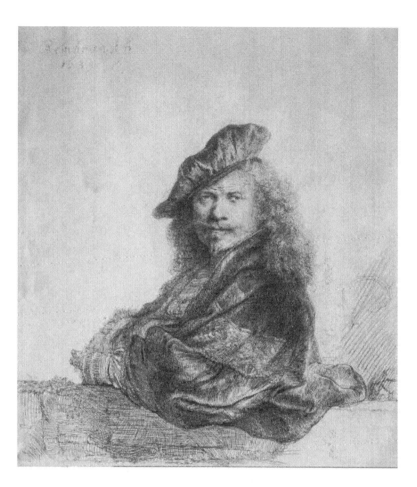

Self-Portrait
1639, 185 x 163 mm

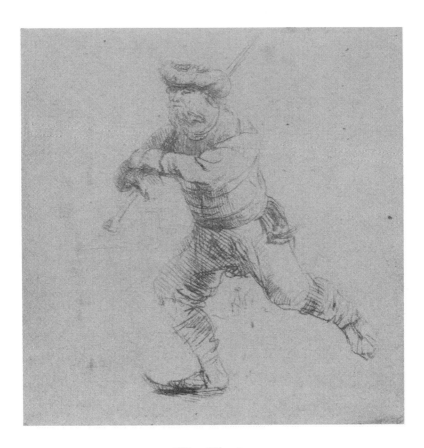

The Skater
c. 1639

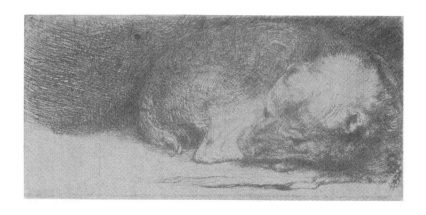

Sleeping Puppy
c. 1640, etching and drypoint

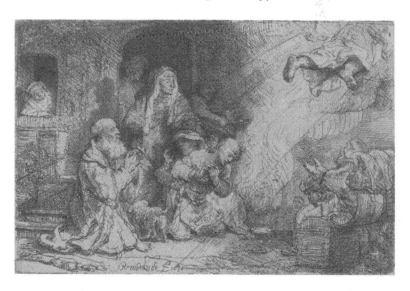

The Angel Departing from the Family of Tobias
1641

Virgin and Child in the Clouds
1641, etching and drypoint

The Spanish Gypsy "Preciosa"
c. 1642

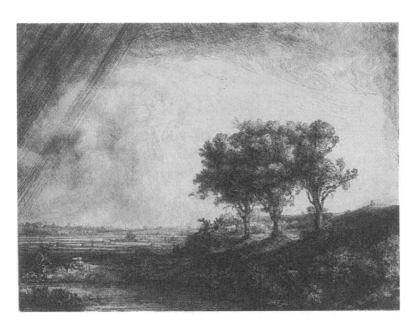

Landscape with Three Trees
*1643, etching, drypoint and engraving in black ink on
antique European laid paper, 21.3 x 27.9 cm*

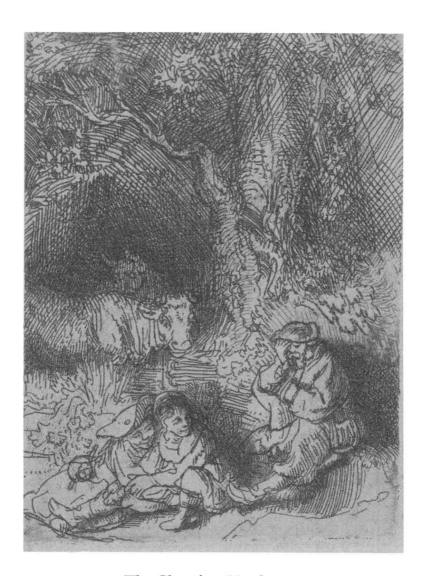

The Sleeping Herdsman
c. 1644, etching and burin sheet, 8 x 6 cm

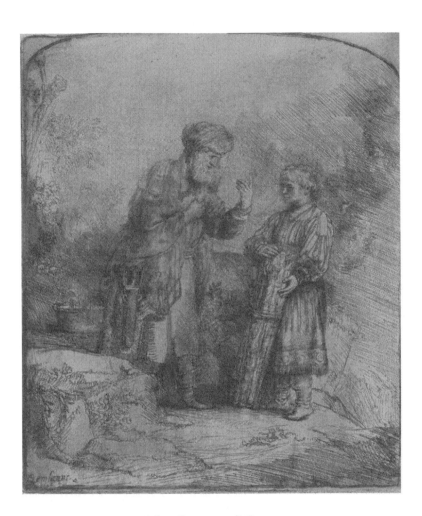

Abraham and Isaac
1645, 157 x 130 mm

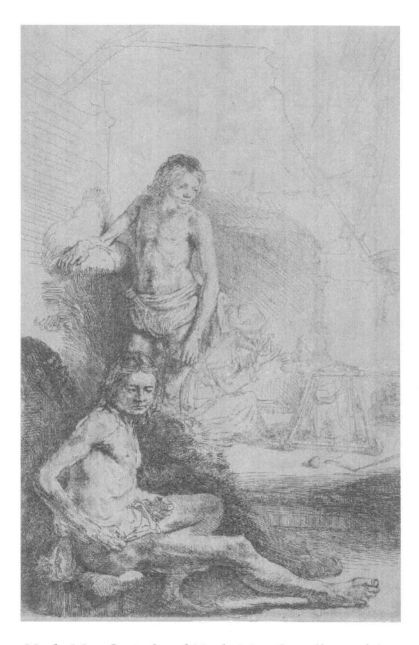

**Nude Man Seated and Nude Man Standing, with a
Woman and Baby in the Background**

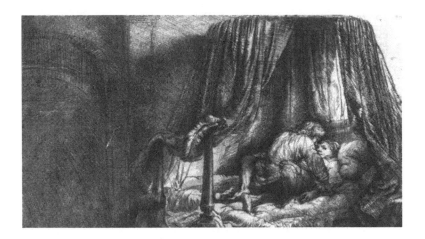

Ledikant
1646

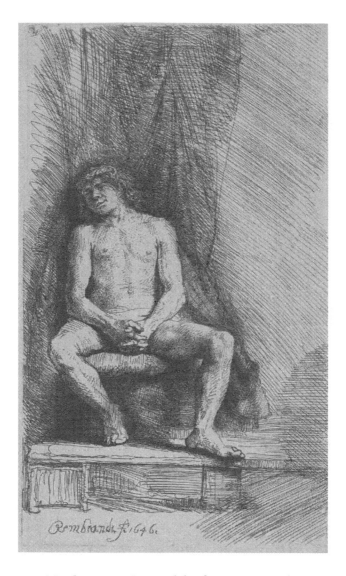

Nude Man Seated before a Curtain
1646, 16.5 x 9.7 cm

Portrait of Jan Six
1647, 240 x 189 mm

Jan Six (1618-1700) was an important cultural figure in the golden age of the Netherlands. The son of a well-to-do merchant family Six, Jan studied liberal arts and law in Leiden in 1634. He became the son-in-law of the mayor of Amsterdam, Nicolaes Tulp in 1655 when he married his daughter Margaretha. Thanks to his father-in-law, he became magistrate of family law and various other appointments on the city council, eventually becoming mayor of Amsterdam himself in 1691 at the ripe age of 73. He was a friend of Rembrandt who painted a remarkable portrait of him.

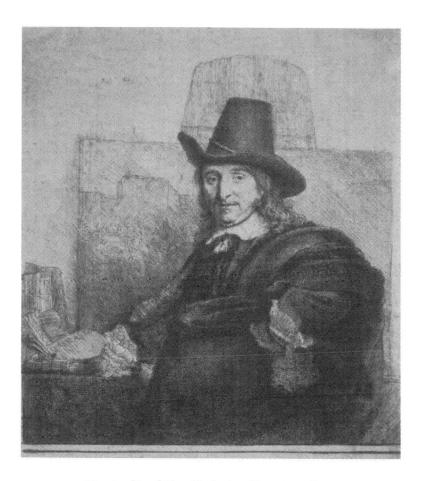

Portrait of the Painter Jan Asselyn
1647, Etching with line engraving, 195 x 170 mm

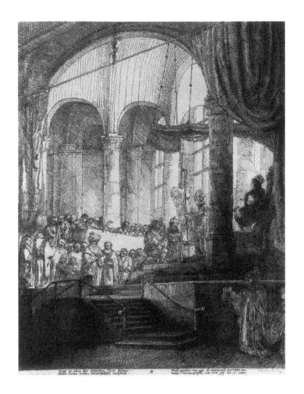

Medea or the Marriage of Jason and Creusa
1648, Etching and drypoint, 239 x 178 mm

The story of Medea is described variously by ancient authors. In the seventeenth century, Netherlandish artists who depicted Medea usually drew upon Ovid's metamorphoses. However, less familiar sources were also consulted, and modern versions composed, Thus Rembrandt's large etching of 1648, Medea or the Marriage of Jason and Creusa was made as a frontispiece to a version of Medea written and published that year by his patron Jan Six.

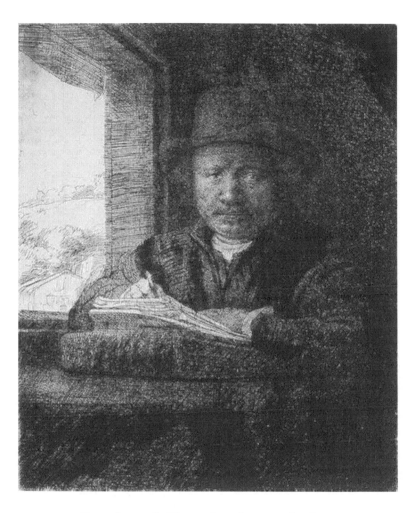

Rembrandt Drawing by a Window
1648, 15.8x13 cm

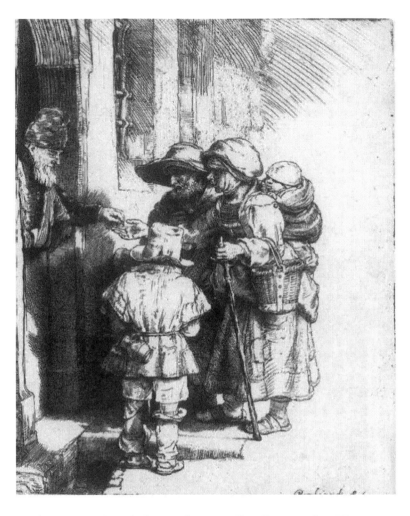

Beggars Receiving Alms at the Door of a House
1648, Etching, burin, and drypoint, 165 x 128 mm

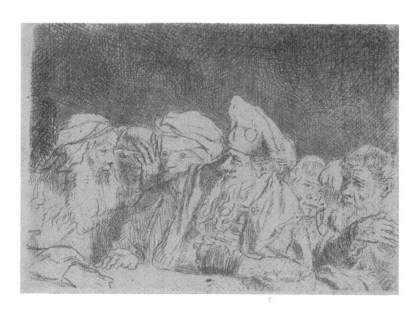

The Pharisees Debating (Fragment from the Hundred Guilder Print)
c. 1649, etching with drypoint and engraving on laid paper, 14.2 x 7.5 cm

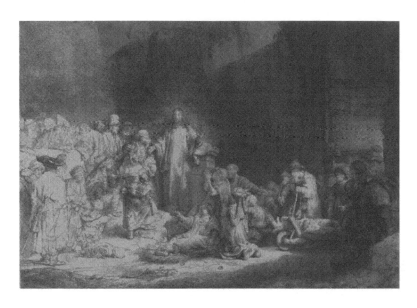

The Little Children Being Brought to Jesus ("The 100 Guilder Print")
1647-49, Etching and drypoint, 1st state, 278 x 388 mm

The so-called Hundred Guilder Print is Rembrandt's most famous etching. Rembrandt began to make studies for this celebrated print earlier, but in its main types and in its final decisive achievement the etching belongs to the beginning of the mature period. The popular title, found in the literature as early as 1711, is derived from the high price the print is said to have fetched at a sale. According to an anecdote recorded by the eighteenth-century art dealer and collector J.P. Mariette in his Abecedario, it was Rembrandt himself who paid this sensational price for an impression of his own print.

The etching illustrates passages from Chapter 19 of the Gospel of St Matthew. Rembrandt treated the text with liberty; he merged the successive events into a simultaneous one, with Christ in the centre preaching and performing his miracles. According to the text, Christ had come from Galilee, a large multitude following, and he began to preach, healing the sick. The crowd looks to the Lord, waiting for their turn to be healed. Near the centre, to the left, a young mother with a child advances to Jesus. St Peter interferes, restraining her, but Christ makes a counter-movement. It is the moment when he says the famous words: 'Suffer the little children, and forbid them not, for of such is the kingdom of heaven'.

In addition, this chapter of St Matthew contains the story of the rich youth who could not decide whether or not to give his possessions to the poor and follow Christ's teachings. The young man is seen sitting to the left, in rich attire. Here too, on the upper left, are the Pharisees, arguing among themselves, but not with Jesus, as in the text. Warmth of feeling seems to emanate from him, spreading balm on the suffering souls of the sick, the poor, and the humble. The spell of devoutness and the intimate spiritual union of the composition are mostly due to a general atmosphere of wondrous light and shade that hovers and spreads over the whole scene. It is a light that by its infinitely subtle gradations and floating character transforms the transcendent sphere into reality. A miracle which binds visible energies with the invisible and the sublime is performed before our eyes.

The types of the Pharisees in the Hundred Guilder Print are of a more genuine Jewish countenance than those Rembrandt represented in his early works. Late in the 1640s he began to watch Jews more carefully, and to characterize them more deeply than before.

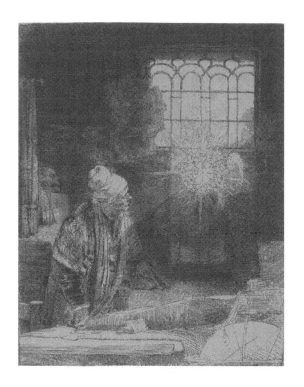

Faust
1650-52, 209 x 161 mm

The title of the picture is questionable. It shows a scholar at the moment when a supernatural appearance (with definite Christian symbols in it) attracts his attention and causes him to interrupt his work and rise from his desk. One realizes at once that Rembrandt's conception of a scholar contains supernatural elements, and we are made aware of the mysteries inherent in the spiritual world. The light is arbitrary, expressive of a spiritual content beyond the power of man; the space is subordinated to the chiaroscuro device, and its rational construction is less essential than the expression of some deeper emotional content.

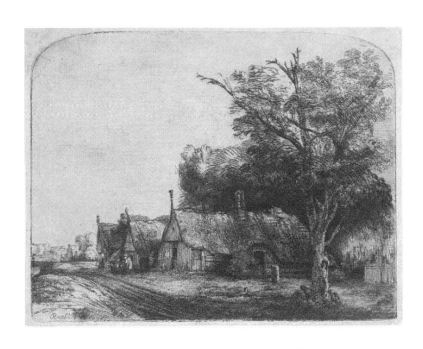

Landscape with Three Gabled Cottages
1650, etching and drypoint in black ink on European cream-colored antique laid paper, 16.2 x 20.3 cm

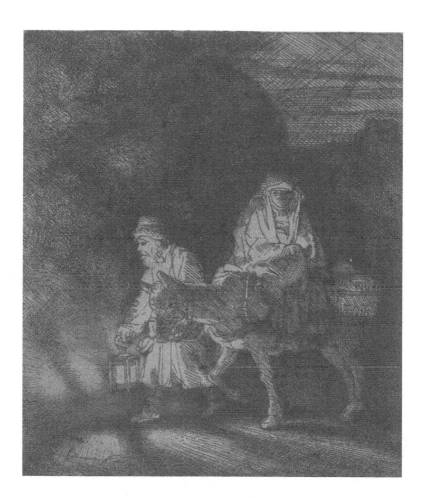

The Flight into Egypt
1651, 12.6x11 cm

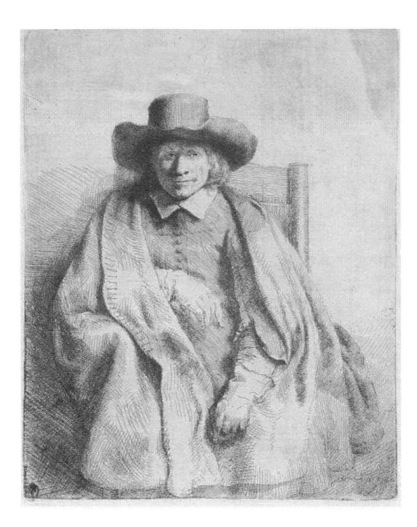

Clement de Jonghe,
1651, etching, printed in black ink on cream-colored
European antique laid paper, 20.6 x 16.2 cm

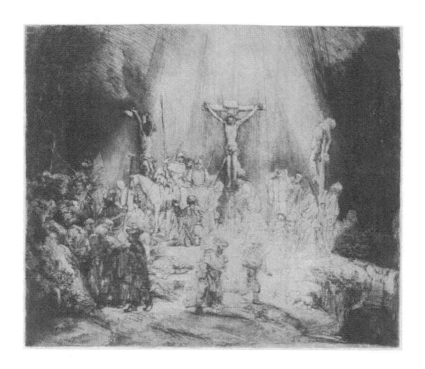

Christ Crucified between Two Thieves (The Three Crosses)
1653, drypoint and engraving, printed in black ink on cream-colored vellum. 38.4 x 44.8 cm

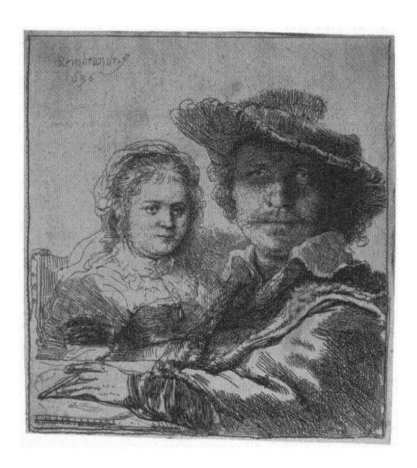

Self-Portrait with Saskia
1654, 104 x 95 mm

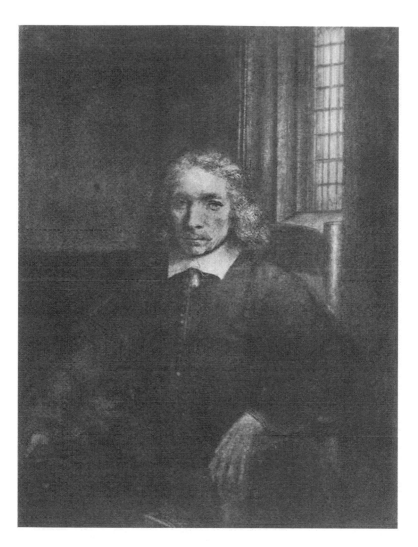

Peter Haringh
1655, Etching, drypoint, and burin, 195 x 146 mm

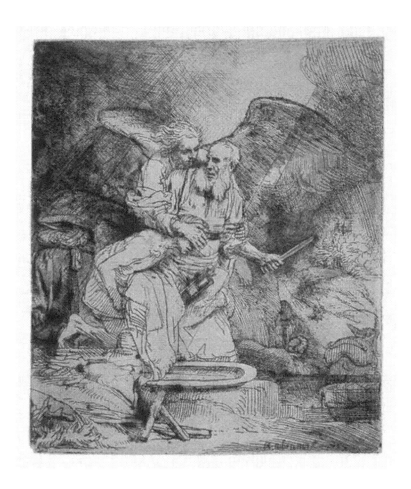

Abraham's Sacrifice
1655, 15.6x13.1 cm

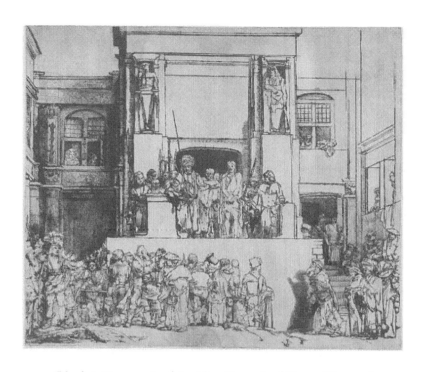

Christ Presented to the People (Ecce Homo)
1655, drypoint, printed in black ink on cream-colored Asiatic wove paper, 38.4 x 45.1 cm

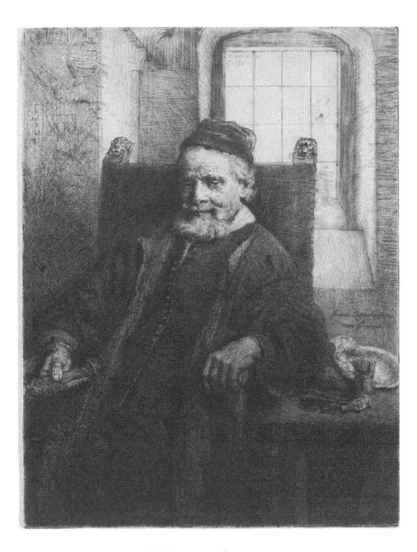

Johannes Lutma
1656, 198 x 149 mm

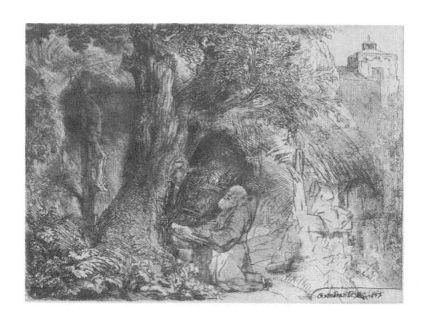

St. Francis Praying Beneath a Tree
1657, drypoint, etching and engraving in black ink on dark cream-colored laid paper, 17.9 x 24.4 cm

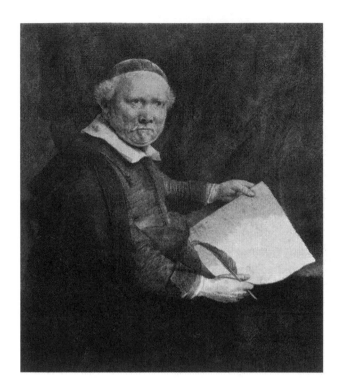

Lieven Willemsz van Coppenol (the "Large Coppenol")
1658, Etching and drypoint, 340 x 290 mm

Lieven Willemsz van Coppenol (c. 1599-1671) was a well-known calligrapher. His family originates from the Spanish Netherlands from where his grandparents fled and settled in Haarlem about 1579. Van Coppenol appears to have taken part in the development of calligraphy at every level, from schoolboy competitions to publishing, teaching, corresponding with peers, and finally striving, obsessively, to be recognized as the greatest calligrapher. He was far from achieving that distinction, although he had considerable skill.

Van Coppenol's first commission for a portrait from Rembrandt was for a portrait print of modest size, the "Small Coppenol." This print shows the portly writer at his desk, pen poised above a perfect circle. Rembrandt drew a compositional study for the etching, which then went through major revisions in several states. (The present picture is the fifth state of six.) Apparently it never pleased the patron, Rembrandt therefore proceeded to make the larger etched portrait of Van Coppenol (the "Large Coppenol," which is the artist's largest portrait print. For the Large Coppenol Rembrandt painted a preliminary sketch in oil.

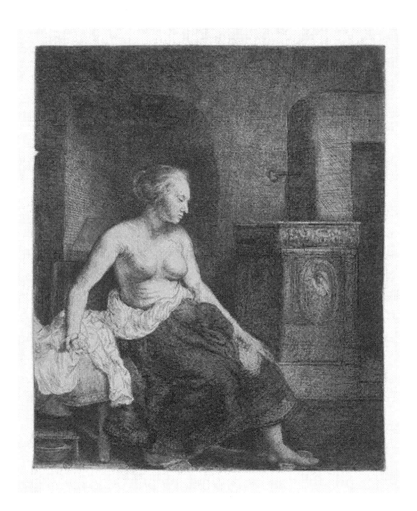

Half-Naked Woman by a Stove
1658, 22.6x18.6 cm

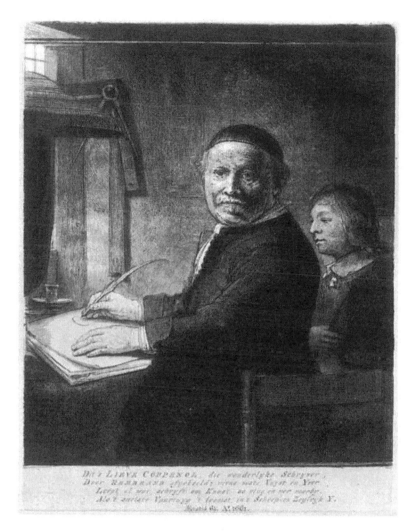

Lieven van Coppenol with His Grandson (the "Small Coppenol")
1658, Etching and drypoint, 258 x 190 mm

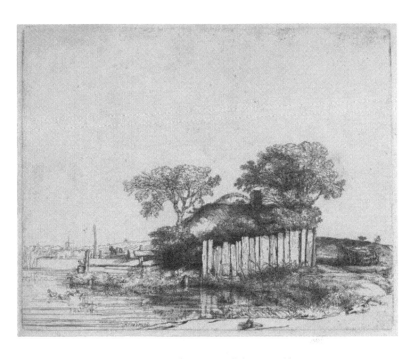

Cottage with a White Paling
N.d., etching, printed in black ink on dark cream-colored antique European laid paper, 13 x 15.9 cm

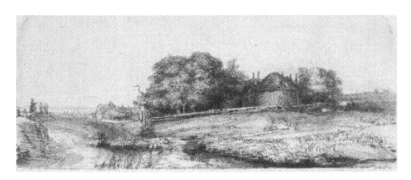

Landscape with Haybarn and Flock of Sheep
N.d., etching and drypoint with sulphur tint in black ink on cream-colored laid paper, 8.3 x 17.5 cm

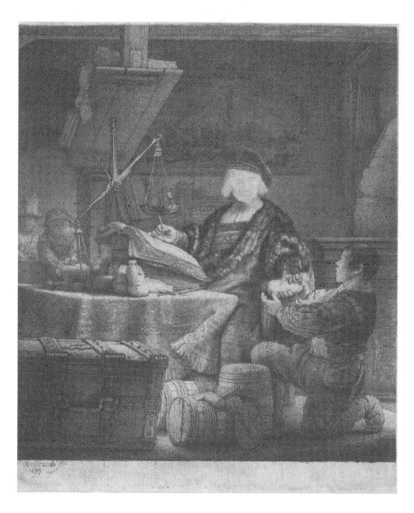

"The Goldweigher"
N.d., 24.6 x 20.2 cm